A Sea of Voices

Women Poets of Israel

A Yam שel

Golosov Un Mar d

Voces ים פוקוילעס Yam she

Kolot Un mer de Voi

A Yam shel Kolo

бюджетн A Yar

funkeler ריך ים של

מיסה More Goloso

Un Mar de Voces

Yam shel Kolo U

بحر الأصوات

mer de Yam sh

meer von stimmen ים של קו A Yar

Kolot бюджетн A Yar

Also available by Majorie Agosín
from Sherman Asher Publishing:

Invisible Dreamer: Memory, Judaism, and Human Rights

Lluvia en el desierto / Rain in the Desert

Miriam's Daughter: Jewish Latin-American Poets

Poemas para Josefina / Poems for Josefina

Madre, háblanos de la guerra / Mother, Speak to Us of War

La plenitud de los objetos invisibles / The Fullness of Invisible Objects

A Sea of Voices

Women Poets of Israel

Edited by
Marjorie Agosín

SHERMAN ASHER PUBLISHING · SANTA FE

Design by Jim Mafchir
Edited by Nancy Zimmerman

Sherman Asher Publishing
P.O. Box 31725
Santa Fe, NM 87594-1725
www.shermanasher.com westernedge@santa-fe.net

Printed in Canada

A Sea of Voices *coincidentally has seen publication just as Israel is celebrating its 60th birthday. The compilation of this anthology began four years ago as I traveled to Israel and listened to a multiplicity of languages, it is a tribute to that nation, to the poets who create and live there, and to those who continue to write in the languages of the Diaspora. I believe that through poetry, nations at war can heal. It is my hope that A* Sea of Voices *will plant a small seed, cultivating a growing dialogue among different peoples and different languages.*

Acknowledgments

I want to thank the poets who so willingly shared their own work and that of others with me, making this anthology an act of generosity. I want to especially thank Karen Alkalay-Gut for her help and encouragement in guiding me with the Arab poets. I'd also like to acknowledge Ilana Hornung-Shahaf for her commitment to this project, as well as Rachel Back, whose suggestions and guidance have been invaluable. A special thanks goes to Rami Saari for his wisdom, understanding, and careful reading of the introduction.

Without the constant support of my publisher, Jim Mafchir, this book would not have been possible. I thank him for his vision, good humor, and faith in what I do. I also want to thank Nancy Zimmerman for her meticulous editing of this complex collection as well as for her inspiration and dedication.

This book was written in the peaceful artists' retreat of Mishkenot Shahananim. I thank all those who made my stay so beautiful, especially Liat Cohen, whose generosity helped me understand that poetry is a path to peace.

Table of Contents

Foreword

Poetry originates from the human voice, its intimacy like a murmur or a song intertwined with ancient roots and textures. Since earliest history, poetry has emerged from a primal need to sing out loud, to feel its breath. It is a form of prayer, a communion and faith that empowers us. It is a language that understands sorrows and joys.

In Israel, the spirit of poetry has lived from the time of kings David and Solomon to the modern day as a powerful amalgam of ancient and modern language. At any given time of day Israel's cities are filled with voices, those of its citizens as well as rabbis, priests, and nuns who sing and pray. Among them are voices of pain, sobs from women in front of the Wailing Wall, of those mourning the dead, of women who remember the dark color of war. Israel is a place immersed in a sea of languages, a sea of conflicts.

A Sea of Voices showcases the work of twentieth-century women poets who have lived or still live in Israel and write in multiple languages. The section on Hebrew poets is the most prominent in the collection and brings a diversity of poetic tradition from Ashkenazi to Sephardic. The poets who write in Hebrew belong to a variety of places and regions, and it is the Hebrew language that unifies them. And yet, one hears diversity in their respective languages: Hedva Harechavi, for example, writes in Hebrew but recognizes the hidden truths of her Israeli ancestry, as does Sabina Messeg, whose first language is Bulgarian. As in all anthologies, selections can be arbitrary, but at the same time I have chosen the poets who have touched me most deeply, who have spoken about history, its power, and its intimacy.

I compiled this Sea of Voices in the outskirts of Tel Aviv, a

bright city by the sea, a Mediterranean port where voices continually arrive. The sea was fluid, a turquoise texture, a hybrid movement of waves, and the sun shone calypso-pink, curving between the sea's textures like my hands over my notebook. My body was filled by sounds. An old couple was strolling and speaking in Yiddish. A young Ethiopian danced while gazing at the horizon. Two Russian girls were smoking an Arab pipe. I thought of Jerusalem as well, a place of poetry and promises. This is Israel, a country united by different cultures and diasphoric roots, and shapes that conjure visions of other ports.

The creation of the state of Israel is connected with the revival of Hebrew, a language that has always been a vibrant and quotidian part of a literature whose antecedent is the Bible but which lay dormant for more 2,000 years. It has always been necessary for Hebrew to be at the center of Israel's collective imagination and sense of nationhood. But the languages of the Diaspora have also existed; people have spoken them in their homes, telling of their dreams, their recipes, and their tenacity to retain their languages, especially Yiddish, which has been spoken for centuries by eastern European Jews.

The constant flux of emigrants crafts the mosaic that is present-day Israel, creating a unique identity of place and a diversity of languages that characterized this land even before the state existed. In the small town of Safed, the first emigrants were the Sephardic Jews expelled from Spain and later Morocco who spoke Ladino and still speak it to this day. The center of Jewish mysticism, Safed became a community where poets and mystics could live together and create. The language of this era is Ladino, which evokes a unique poetic imagination that is a part of Israel, both in its ancient sense of self and its modernity.

It is said that modern Hebrew poetry began in the eighteenth century with the work of Moses Hayim Luzzato, who first lived in Italy. Luzzato liberated himself completely from the Arabic tradition and redefined the biblical genre, creating his own lyrical poetry and thereby promoting the Europeanization of modern Hebrew poetry.

It is impossible to fully document the complex and long history of modern Hebrew poetry. Nevertheless, a majority of the

poets in the first part of the twentieth century were born in Eastern Europe and brought with them their childhood languages and the Hebrew they learned in the *cheder*. I believe that Ladino, Hebrew, Arabic, and Yiddish are the foundational languages of Israel today; together they form a confluence of presences, histories, and inhabitants from the conceptual communities of the Diaspora.

Contemporary Israeli poetry is thus rich in tradition; it's an amalgam of ancient poetry, mystical and modern. The multiplicity of roots is what defines it: It is a poetry that interrogates, that has inherited poets such as Leah Goldberg, Zelda, and Yehuda Amichai, among others. But it also introduces a unique voice informed by Israel's decades of turbulent political history. And, like the ancient poets, their modern counterparts question their own destiny and purpose in the contemporary world, both their precarious homeland and their new home, Israel. Their poetry often embraces minimalism—the lack of punctuation creating a plethora of ambiguities—but it is precisely this ambiguity that inspires the reading of it, a poetry both modern and ancient, one that unravels history.

This collection also resonates with my own history. I am a Chilean poet living in the United States, writing in Spanish and consistently being translated for an English-speaking readership even though there are more than 40 million Spanish-speakers in the country. Here in the United States, poetry written in Spanish addresses a marginal readership within the dominant subculture of Latino literature. The discourses about what it means to speak a language or multiple languages have affected me personally and united me to the same debates surrounding contemporary literature in Israel, a multilingual and heterogeneous country where there are connections among people who read and write Polish, Ladino, Spanish, and Yiddish literature.

In spite of the constant wars affecting Israel and its neighboring countries, there is a sense that Israeli culture, over the last two decades of post-Zionism, is vibrant and creative, and there has been a burgeoning of women's literature from the 1970s to the present. Festivals, like the prestigious International Jerusalem Poetry Festival, and the distinguished publishing houses dedicated to poetry in Hebrew as well as in translation make Israel a country that vibrates

with the sounds of poetry.

Although several anthologies of Israeli poetry have been published, this volume is unique because it emphasizes the confluence of Israel's many languages, histories, and Diasporas. If Hebrew, Arabic, Yiddish, and Ladino have been central for the history of the Jews, they also have served as instruments of knowledge, travel, and freedom because the poets have come from so many places. The coexistence of these languages in Israel is happening more today than ever before, its multilingual culture defining it as a country throughout its short but complex history.

Authors such as Agi Mishol and Sabina Messeg came to Israel from Hungary and Bulgaria, respectively, at a young age. Margalit Matitiahu wrote her first poems in Hebrew, but then decided to recover the aroma and memories of her Greek and Spanish ancestors by writing in Ladino. These women have chosen to write in Hebrew as well as other languages, reflecting the characteristics and echoes of many places, and this is the essence of *A Sea of Voices*.

This collection invites the reader to reflect on the enigma of identity, and explores that identity through poetic voices. Each of these voices evokes and reflects on both personal and collective histories. These are the voices of poets who are enveloped in the history they have lived, but who also rewrite history to make it their own. They are audacious, with gifted imaginations, participating in the fluidity of braided tongues, overlapping one over the other.

A Sea of Voices emerges into a historical confluence at a time of importance and meaning for Israel. The country's identity has solidified, and I feel that Israel is now able to reassess its past and recognize what it has inherited: the glory of different languages and cultures. Poets are the ones who reconstruct histories great and small; they rescue melodies, praying and singing through their creativity.

Two foundational poets appear in this section: Dahlia Ravikovitch and Yona Wallach. The first is, by far, the greatest Israeli poet; her voice, universal but also very Israeli, transcends geographic spaces. It represents the history of the Diaspora, but is also original and imaginative, occupying a central place in contemporary Israeli poetry. As the noted American poet Stanley Kunitz says, "Her song is both ancient and new and it is unutterably poignant." This complex poetic art is also found in Yona Wal-

lach's poetry. Wallach speaks of desolation as well as of the Bible, providing commentary on poetry's destiny and the imagination itself.

During the last few decades, Israeli poetry written by women has resurfaced and spread on an international scale. A country the size of New Jersey, Israel has produced books and readers in numbers comparable to those of the world's largest countries. Israeli poetry is part of its history; it comes from the voices of the prophets, among them Miriam and Deborah. Contemporary poetry is also part of an ancient history, a poetry renewing itself each day, as expressed by Rachel Back and Esther Raab, who take biblical images and recreate them in a new and feminist style.

Margalit Matitiahu revitalizes Israeli women's poetry in Ladino, reviving the ancient language and making it literary. Through her verses, the reader can hear the cadences of this language that has occupied a place of prayer since the sixteenth century. Her family is originally from León, Spain, but was later displaced to Salonika, Greece, and many of her family members were killed in the Nazi concentration camps. Included in this anthology are texts related to a particular clarity of experience. We can observe how the Holocaust had repercussions in the Sephardic communities of Europe, in Greece as well as Bulgaria. Sabina Messeg's poetry originates from Bulgaria and has the power of evocation, conjuring these times of expulsion vis-à-vis the Israel of today.

The modern and the new, the world of conflicts and the Divine, bring a unique vibrancy of those who write in this land. The poetry of Rachel Zvia Back also addresses life inside Israel and its Arab citizens. Tamara Broder-Melnick brings to life, in her native Spanish, the traces of a life left behind—after the Holocaust and again after a wave of constant journeys. All of these poets attest to the complexity of life in a country whose turbulent history undoubtedly informs the creation of art, a country that continues to struggle to survive despite having achieved many of its goals, constantly at war and judged, for better or worse, by the rest of the world.

Poetry finds a way of being read on its own terms; its essence is intimacy and community, and it requires a space in time and a conscience illuminated by sounds and voices that often are just barely allowed to be heard. The reading of these poems is a read-

ing of voices, of memories and echoes of other times as well as the here and now. Two of the poets writing in French have lived in Israel for more than two decades: In the work of Gali-Dana Singer we find the voice of Ahkmatova, a voice that denunciates, implores, laments, and influences poems by Esther Orner and certain characteristics of a francophone inheritance; the short poems by Marlena Braester echo the surrealist tradition.

Living in Israel requires a certain seriousness of purpose. Life is always uncertain, and many poets, especially Agi Mishol and Shirley Kaufman, reveal their power to speak about the unspeakable, to expose the madness of the every day, such as suicide bombers and their victims. These poets defiantly and courageously write about the living history that surrounds them. Poetry finds seriousness in the rhythm of history that appears as a constant—in a daily life full of fear that allows us to achieve the intimacy of the soul, in the small details of the quotidian as related to the miracle of being and, more than anything, to the consciousness of feeling alive. This intimacy is revealed to its fullest in the poetry of Linda Zisquit, Lisa Katz, and Shirley Kaufman, English-speaking poets living in Israel today between the borders of language.

These poems should be read over and over again in order to reflect on them, to pause, to feel their quietness, and to come closer to the lives of these poets, imagining where they lived, the language of their mothers, their current embrace of Hebrew, and their desire to write in this language of the here and now. These works, more answers than poems, contain questions and histories, and we must allow ourselves to be carried by them in order to feel them.

In the celebrated words of Mexican master poet Octavio Paz, "Poetry is an act of solitude and communion, of intimacy and history." The poets in this anthology live a history of communion, a quotidian and universal history, which is the destiny of the Jewish people who have had to live and use the word "destiny" as a form of acceptance of history and its ephemeral quality. Horror and love have a dialogue that flows; it is a poetry that meditates, as in Shirley Kaufman's poems, where she speaks about the realities for Jerusalem and how it feels to be a witness of this time. It is a poetry that enters the soul and teaches it to rethink and fortify itself.

The poems in this anthology fluctuate between personal and

historical spaces, as exemplified by the title of one of Kaufman's poems, "Thresholds." These thresholds are those of the Diaspora, of the borders between language and Israel. As Kaufman says, "Waking in bed in the shrill dark/ sounds in my head/ without language trying to sort out the pieces, / matched fragments held up to a one-way mirror." Language is in constant dialogue with itself, conscious of its being and living between fragmented worlds, of imagination and love for two histories, two ways of being. When speaking about Linda Zisquit's poetry, American poet Rita Dove says that it "stands at the crossroad of several roads—European and Arab-American individualism, tribal law, the Jewish Diaspora, and Palestine."

A Sea of Voices is a collection that asks and elaborates on such fundamental questions as language and identity, poetry and landscape, history and the self. The poets are confronted with questions about themselves, as writers living in Israel and faced with the intersections of cultural dialogues between Israel and the rest of the world. For example, the poetry by Gali-Dana Singer creates a dialogue with the tradition of Russian poetry and alludes to Pasternak and Ahkmatova. Arabic poetry being written in Israel also establishes a dialogue with the resonances of "Adonis of Fadua" by Siham Daud.

Every poetic act is a literary expression, an act of courage, resistance, and a challenge to official histories, wars, and their heroes. This volume encompasses Israel's poetic pluralities whose collective identity is a sea of voices and a chorus of languages both metaphorical and real. The metaphor of place or belonging concentrates on the metaphor of rupture: Israel has been a place of displacement and returns, of meditation and a way of thinking about what it means to live in a dislocated society besieged by violence. The most amazing thing is that Israeli poetry continues to be an essential part of an existence that is connected to life and language as well as hope.

A Sea of Voices is audacious and diverse, showing the ability of language to play with idioms and create dialogues between the past and the present. In the words of the Israeli painter and poet Hedva Harechavi:

To glance momentarily at the anarchy-of-the-internal world…life that

cannot be fenced off or defined, yet without which it would be impossible to create art. To listen momentarily to the intensive dialogue taking place between the creativity of art and the anarchy-of-this-inner life, life that happens deep within ourselves, without our having any idea where it came from, what motivates it, what its limits are, where it begins, where it ends, however much we go over it in our minds it will always remain a mystery: the mystery of the human brain, the mystery of mankind, the mystery of the creativity in art. To briefly cross over the edge and gaze at the image of the anarchy of the internal world… only art, with its pure freedom, and basic tendency to honesty and totality has the capacity to pave the way to the impossible lands of the anarchy of the internal world. And by unique sensitivity and outrage art transforms anarchy into the music of islands of order. Each work of art is a small island of order within this huge ocean of anarchy, music of freedom. Or in other words: art has made our lives wonderful, simply wonderful.

—Marjorie Agosín
Jerusalem, Mishkenot Sha'hananim

Introduction

I returned to Israel in January of 2006. Winter on the Mediterranean is generous, and the sun at midday caresses me; it is tender, but also threatening. I returned to Israel to meet all of the women whom I have read about over the years in order to know them intimately as poets and as women living in *A Sea of Voices*. Poetry should be read slowly, acquainting oneself with it gradually, just as one discovers another's voice in another part of the world. This is why I have returned to Israel—to sit myself down with each of the women whose work appears in this book and, by way of their words, experience their feelings and infer what it means to live and write in Israel today, a country besieged by war.

During the first few days I walked along the shores of a titillating sea, a sea whose delicate waves suggested the power to imagine voices, and I could feel, alone on the beach, the mist that lifts the city of Jaffa. Beyond Jaffa to the west appeared the white city of Tel Aviv, as if it had always promised to tell its story. I allowed myself to be taken by the intensity of the moment. I was in Israel, and only here could I hear the voices of the Mediterranean, the voices of the Middle East, Europe, and Latin America, those who had arrived at these shores or had always lived here. This sea of voices soaked into my skin, and the histories of diasporas, of the exiled, united in them.

Over several days I met with most of the poets included in this book. I wanted to see their faces, the outlines of their bodies, always luminescent, and I especially hoped to hear their voices, a plethora of voices. And this is how I met with Tal Nitzan, who was like a sheltering port. Nitzan speaks perfect Spanish, with all its

1

rhythms and peculiarities, and is known as one of the most excep-
tional translators from Spanish to Hebrew. And, I have discovered,
almost all of the poets in this book are also translators. Nitzan has
translated everyone from Pablo Neruda to Alejandra Pizarnick and
Juan Carlos Onetti. We were two women from different continents
sharing histories: This is the spirit of our book, and I say "our" in
a gesture of solidarity.

We spoke of the great South American writers, of the down-
to-earth and beautiful poetry by Pizarnick, of her imaginary and
poetic forms that translate well into Hebrew. Translation is another
way of loving, another way of being in the world, and I feel *A Sea
of Voices* is also a sea of words experienced through other languages.

Nitzan writes in Hebrew and English, just as Gali-Dana Singer
does. I met Singer in the Café Paradiso on a rainy afternoon, so
smooth and light like a woman dancing slowly and covering the
sky over Jerusalem. Our talk started flowing and we shared our ex-
periences of living in exile, noting the relationships that form when
a person is separated from her native language. We discussed Russ-
ian poetry, concentrating on Ahkmatova, rethinking it, readdress-
ing it, and all of a sudden I understood that Singer had inherited
this tradition but that her poetry also moves with fluidity between
Hebrew and English. When I asked her about it, she smiled and
told me she doesn't know why this happens, but she also doesn't ask
herself why, and I understand that the sea of voices is mysterious,
flowing from various languages that are entwined with one another.

I am still in Jerusalem, where most Israeli poets live, a city both
near and far from God and the soul. During our daily walks through
the old city, we are always surprised and frightened.

If poetry is written in collages and fragments, from a private
and public space, then poetry is always historic, and in Israel it is
also the quotidian. Tamara Broder-Melnick tells me that her first
language is Polish, then Czech, then Hebrew. But Spanish has al-
ways been her language of poetry, a poetry rooted in her dreams.
There are some poets who only write in their native language, the
language from their childhood or the one that reminds them of
their childhood. Melnick-Broder says that she only knew how to
say "snow" because she remembered the snow in Prague. I remem-

2

ber my conversations with Galit Hazan Rokem, her exuberance about things, her passion for folklore. I remember her telling me about one of her poems and how it talks about the thousands of ways to say "snow" in Finnish, and how people are still looking for ways to translate it. Rokem writes in Hebrew, but translates Finnish and Swedish to Hebrew in order to bring the nuances of the Hebrew language to life.

The English-speaking poets have arrived as mature voices, with an understanding of how difficult it is to go back and forth between languages. Others, such as Rokem, came from Finland during the 1970s. Unlike Rokem, who arrived in Israel when she was 12 years old, Singer came to Israel when she was in her thirties, but writes in Hebrew. The relationship these writers have with their languages is paradoxical, distinct, and it works in a special way for each of them.

My conversations with Shirley Kaufman flowed. We talked about Chilean poetry, Neruda, and what exile implies. We share a similar history: She arrived in Israel in 1973 during Yom Kippur, and I came to the United States in 1973 when Salvador Allende's government was overthrown. Our histories and our relationship with language, hers with English and mine with Spanish, are parallel. Kaufman is also an extraordinary translator of the great Israeli poets, especially Aba Kovner, the most prominent leader of the revolution in the ghetto of Vilna who later founded one of the oldest kibbutzes in Israel. Kaufman is a kind of older sister to the English-speaking poets and to Lisa Katz, who always seems to look at the world with her openness of spirit. Many of the poems in this anthology have been translated by Katz.

I am always impressed by the melding of delicacy and force by the English-speaking poet Linda Zisquit. Her poetry is smooth, and behind her words there is enormous passion and love for memory. Of all the poets in the anthology, I feel her self-containment and her space. She is different from many of the other poets in this collection, as her experience living in Israel determines a large part of her poetic imagery. Germans who came to Israel in the 1920s built her home; her garden houses her artwork—it is the gallery where she contemplates the outside world that always surrounds the inner sanctum of her creativity.

Unlike Zisquit, Rachel Back writes poetry centered on Israel's reality, the conflicts between Israel and Palestine and their lyric territory defining a dislocated society in a permanent struggle for peace. The landscape in her poems very often is a landscape of pain, as she expresses in "The Buffalo Poems," which are included in this anthology. When we met, we connected through our loyalty to our native languages and also, perhaps, because we live in similar places—she in the Galilee, apart from the more urbanized areas of Israel, and I in Wellesley, Massachusetts. We both spend our time contemplating and writing in our respective homes.

During these times, I often find myself writing in Spanish and English about poets living in Israel. I spoke with them in English, Hebrew, and Spanish, and our languages came together in our dialogue as we contemplated the community of our histories through poetry, which unites us all.

On a beautiful and sunny morning in Jerusalem, I arrived at Miskenot Sha'hananim to meet Esther Orner, and it reminded me of an old friend, a friend I had always known and who came to me with her French accent while I spoke to her in Hebrew, and she could hear the echoes of Spanish in my Hebrew. The poetry in this anthology brought people together and allowed me to converse with Orner and these other poets who reflect their times and the histories of others.

Orner arrived in Israel when she was only 12 years old, and for many years she did not write any poetry. She told me she felt she needed to assimilate and become part of Israel, even to forget the past and forget French. After a while, she realized she needed to write in French and recover her language, her memory, and her history. She writes about the Holocaust and the poetry that characterizes it.

The poetry by the Arab poets exists in its own private space and demonstrates the particulars of conflict between languages and the ways of living, understanding, and displacing oneself. It demarcates the reality of living between languages, cultures, and diasporas. Arab and Israeli poets animate a sea of voices, not as an echo of the past but as a force that flows with the historical and political currents of Israel today. I heard Nidda Khoury read her poetry, a tender poetry that traveled between worlds and borders but still returned to its original place.

4

Mona Daher lives in Nazareth, but something about her suggests that she travels elsewhere. Her work is similar to that of Rumi and to Arab poetry because she writes in order to recover the form's ancient roots.

During ten intense days in Tel Aviv and Jerusalem, the Galilee inspired conversations among the poets in this book. I want to thank them for letting me bring their shared history to this book and for allowing me to travel on the sea of voices they told me about. I learned about the value of writing in Israel today, a country threatened daily by terrorism, where every day the political reality changes, but also a country where poetry flourishes, where women carry pen and paper with them to write about the value of life. This is what I felt when I visited Israel, a desire to live and create in the here and now, and also to be part of a poetry outside of time.

On my last day in Israel, I said goodbye to my friend Michal Govrin, whom I have know for many years. She travels between languages and countries, directing theater productions and working with Israeli and Palestinian students. Govrin exudes the spirit of Jerusalem; she tells me about her city and its people, and whenever I visit Jerusalem I think of her, a poet and novelist who circles not only the space the narrative inhabits but also the space belonging to the lyric with her insistence and strength.

When I said goodbye to her, assuring her that I would return to Israel and Jerusalem, I listened to the church bells, people praying at the mosque, and the voices speaking in Ladino, Spanish, English, Russian, Arabic, and Hebrew. I carry these voices with me and they form a magic box, warm and fragrant, holding the promise of peace through a poetry that unites, that constructs, that is a sea of so many voices.

A Sea of Voices

All of a sudden
I heard
a sea of voices
words
like the water's song
I heard
murmurs and
sediments
the sea's darkness
clarified through a voice
the voices of women
who carried a sea of voices

on the tips of their tongues
on this earth so small and so immense
in this sea that has opened
so many times
ringing like a bell of refuge
for navigators
and all of a sudden I knew that here

I would listen to this sea of voices

these voices like the sea.

By Marjorie Agosín
Translated by J. Rowell

I

FIGS AND JASMINE
Spanish/Ladino

Margalit Matitiahu

Before Arriving to Saloniki

Before departing for the portal of your youth
My mother, I came
To knock on the stone of your immortal home
To tell you that I am leaving
For the place where your spirit grew
Where your father planted in you seeds of poetry.
I feel your quiet suffering
And the stones that have no light
But all was not in vain
I shall whisper in your ear of earth.

Translated by J. Rowell

8

Margalit Matitiahu

Bridges of Time

days fly over bridges
swept by the wind
the road leads to the place
where signs make signs

one moment goes
the other surrenders

routine builds walls
tied by ropes with soft knots

that untie in time
that is born with questions...

one moment has gone
the other has surrendered...

Translated by J. Rowell

Margalit Matitiahu

Pale Shadows

Like shadows
In a funeral procession paler than death
We were carrying your dresses
From your absent house
Breathing the tired sweat
And the horror.

As children touched by fire
We come, your children,
And more and more your spirit
Gives us strength.

Translated by J. Rowell

El Lumbroso
(in honor of Luis de Carvajal el Mozo)

That night I was so radiant
You could barely see me for my light.

Now in the incandescent dawn
I am paraded before your helpless eye.
The stakes are high
Enough for me to see my angel cry.
Padre Contreras, frail and vulnerable
Murmurs why?
Hark! The flames' voice is cracking
Hear them sigh...
My flesh imploding in the fire
Together we witness it reduce to ashes
Together watch it fly.

You and I,
How we danced ever closer to the flames
—to my flesh, to its demise
Your old soul knows I could not die,
But your mind is young,
Cannot yet read the milestones of the sky.

Cloistered in my afterglow
Shawled in me
You stood in prayer
That the light I have become
Be bestowed
Upon you.

My apparition soars
Carried in your dreams.

Four hundred years in the abyss
Cannot erase
The seal
Our memories
Call
I can still embrace
Can enter you
Breathe my eternity into your soul.

Translated by the author

Schulamith Chava Halevy

Migration

The storks return to
circle over fertile
fields at the foothills
of Yerushalayim

We watch them move in
graceful disarray and
sway like mystics
in the marbled liquid sky

I pray for a child, we
must go on, I say, so
many souls still
drift and pine

to be reborn in
flesh. Just one
for me or mine

I feel the rhythm
in my spine
remember Spain?

We saw storks
nest in broken
belfries inside

Ávila, I think storks carry
exiled souls with them, from
there to here from
stone to pine

Here, de León in his
splendor, the hundred
hunted in the auto-da-fé
of 1499

And still church bells dong
although so long
ago the *shofar* sounds
had died

dong! And the cries from
tortured ones by
rack by wheel by fire

a stork dips wings in
ashes, then spreads
them heaven-wide

she glides, comes
near and rests
before our dazzled eyes

silently we ask for
memories of lives
expired

glad that we understand,
the bird unburdens them
and flies

Translated by the author

Tamara Broder-Melnik

Accommodations

Jerusalem
Is
Perfectly
Divisible—
Men
On Earth
And
Gods
In the Sky

Or vice versa.

Translated by J. Rowell

Tamara Broder-Melnik

Breaking the Silence

I was born,
I grew
In a field of scars.

Your heart brings silence
Drags it, turns it off.
Can I disturb silence?
Break it, close your wounds?
And at the departing hour,
How will we separate ourselves
If from the beginning we have been
Tied down by barbed wires?
Come, we invite you to the shadows
Living among us,
For a Last Supper.

The time has come
To put them to bed, cover them in a floral bedspread
For the rest of the night...
So we will have
More pure air,
More open fields.

Translated by J. Rowell

Tamara Broder-Melnik

Children's War

They fall
From rubber bullets
And bombings
Like truncated dummies

Throwing rocks at us
With the transparent
Hands of adults.

They fly
With dynamite and nails.
Falling, they never rise.

They are children
At the service of Allah.

More children fall.

If they rise,
They are limping.
Their parents have brought them
To live in the battlefield.
They fall, on the way,
Shot down by machine guns.

They are children at the service of Jehovah.
The children lose
Eyes, ears, heart, blood
Life.

For the Promised Land.

Translated by J. Rowell

Noga Tarnopolsky

Khamsin

Even its name sounds like frustration
the hot desert
catching in your throat
and languorous oriental seen
bewitching.
It is the restless soul of summer
pulling in for a day, nervous
dusty,
savage,
resisting change
protesting something—

dislocation stalks us from within.

Only the upright, hope-filled pines
scratch and strain for water
against this wind
that seems itself
electric or unwell.
It is the dry current that blows
between lovers
kept from each other

passion deferred again.

Translated by the author

Noga Tarnopolsky

Question

How one night's slippage turned to this:
the question bared first in a kiss
ten years coming, a commotion
so sweet, fine and free, precaution
flew; the leap friend-to-temptation
leaving us in desecration
of the single thing we'd dismissed
and assumed would ever persist:
a world replete with ritual
of approach, fear and withdrawal
by now ingrained, habitual
and sacred, as witnessed by all.
Islands craving not to be revealed;
Praying, rather, to remain concealed.

Translated by the author

Michal Held

Isle of Roses (or Pomegranates)

The wild streets of Rhodes
are all vacant to my eyes
blue waves of joy run to shore
I see a *mikveh*
of tears

When Evreon Martyron Square dons color
my eyes see only shadows
of infants old people men and women
expelled
Ladino on their tongues

Past midnight the old town fills with Greek music
strains of longing
but I only hear the maidens
who once sang here

Throw yourself into the sea they sang to the bride on her immersion
and where she emerged an almond tree bloomed
between the river and sea the groom already waited
when a quince tree sprouted
before them

Wrapped in my soul I stride along the lanes of the Isle of Pomegranates
when before me I come upon a Turkish bath all sealed and shut
with no
immersion
and no
bride

and only I plant almond and quince trees
between the sea and the shore
within me

Translated by the author

Michal Held

Wearisome Nights / Dando bueltas por la kama

A thousand and one nights dreamless we spent
no teniamos suenyo kuando viajimos
sharing a quest in sleep as we voyaged
inward

On ship ferry boat train
Stopping at Kushtandina tasting figs in Crete
and in Jaffa
searching for a dream to the light of Aladdin's magic lamp
a thousand and one nights
we spent
dreamless

And when we had no dream
I was silent

And we shared wearisome nights until we reached
the marzipan point *el punto de masapan*
for which the women of Sepharad yearn but only the most
 wondrous
reach

And returning to Jerusalem we knew
that even in dreamless wearisome
thousand and one nights
there are pathways of milk and honey
Kaminos de leche i miel

Translated by the author

Michal Held

Trees / Arvoles

A Ladino song *torno i digo ke va ser de mi*
Wandering I ask what shall become of me

In the song trees cry for rain and mountains for air
arvoles yoran por luvias i montanyas por aires

In the song an angel stands upon me beholding me with his eyes
and I beg to cry
but cannot

And you in the song are draped in
white
white flowers are dropping from you
from your beauty

When I sing this song once chanted by Sephardic women
draped in white and shedding white flowers
in Izmir and Salonika in Jerusalem and Tangiers

When I sing this song
trees cry tears of rain and mountains tears of air
cry for you singing women who have vanished from the world
leaving your song inside me
deserting me to wander and sing *ke va ser de mi*
what shall become of me and to seek
the angel

Translated by the author
I thank my friend Evelyn Abel for her illuminating suggestions that contributed
to the English version of the poems.

Elvira Levy

Ears and Memory

> *Break open the rock*
> *that will spout water*
> *and the people will drink.*
> Exodus, 17, 1

Water spouting from the rock,
fountain, glass, mirror
patrolling memory.
Image from a yesterday not so far away
not wishing to stay in the shadows
allow your eyes to fix themselves
remind themselves of a lost sun
beyond the sinister history of other times.

The People:
You and Me, all of us,
we are here in liberty and waiting.
The ears don't fold
even though ancient sabers purr off in the distance.
The ears don't fold, no.
Their grains will fall over the sweat of the earth
and they will rise anew
the species, the dawn
and the man walking on the steppe.

Translated by J. Rowell

In Toledo

Toledo, the clean air the dust from your walls,
tightening in the labyrinth of your streets,
kisses the stones I love so much.
Beside the shadows of trees,
night makes itself magic, reality or dream.
The *juderías*[1]—exhausted for centuries—
wake from their lethargy.
They hear songs
rising from the windows.
The synagogue resurges like burning firewood.
Again time is born from the walls
—white lace. Hands thirsty for love
over the books, clothing,
the polished wood, furnishings.

Time is born in Toledo
while I, here,
eternalize in the illusion of hours.

Translated by J. Rowell

[1]Jewish sections of Spain (in this case, of Toledo, Spain).

Elvira Levy

The Sound of Exiles

He took the stone that was placed
under his head and made
a wake and poured oil over it.
Genesis, 28

Bet-El: The House of God.
The waking of man. The dream of the world.

A stone pillow
wiped by Jacob's eyes
who went looking for himself.
And some steps newly flowered
towards the open sky.

And there was a sound of the future
A sound of exiles.

Afterwards, nothing and everything happened.
Guilt wasn't far away:
It became our flesh,
wanderers of honey and salt.

Pilgrims who wander without memory,
pieces of life in merchants' hands.

Stone, consecration of night, that night
lost in ancestors,
dinosaurs, when will you return?
When will we again be
brown wakes loved by the wind?

Translated by J. Rowell

25

Diana Frida Aron

Diana Frida Aron,
your memory will live on
in Villa Grimaldi
forever:

For all the words
you did not write,
and the hours,
and the days,
and the years,
you did not live,
and the children
you did not have,
and your guitar's music
forever silenced
when the murderers
cut the strings
of your soul.

The sinister, the terrible
will blur
the moment that
your shrieks
turned
first into screams,
then into
moans,
and later
into murmurs,
and then
into silence.

Your spirit shall live
Diana
in the history
of this country
this long strip
inundated with blood
but that defeated dictatorships
and crowns itself today
with liberty and democracy.

Your memory will endure
in Villa Grimaldi
in the smooth skin
of the apples,
and maybe Diana,
like in the Araucana
legends,
you will be reborn as
a rosebush
completing your
unfinished life
in an eternal ritual
of roses

Every time your name
is pronounced:
Diana Frida Aron
the echo of your voice
shall resound in Villa Grimaldi:
I am here, here, here

Translated by Monica Bruno Galmozzi

Sylvia Aron

We Will Return to Genesis

We will
return
to Genesis
and be
Adam and Eve

We will
ride on horseback
through the tangled
aged trunks
and moonlight

We will
dig
in the thicket
until we reach
the deep
scream
of the earth

We will
burn ourselves
in your fiery
hindquarters
as well as in my bonfires'
haunches.

Translated by Monica Bruno Galmozzi

Sylvia Aron

Who Directs the Orchestra of the Sea?

Who directs
the orchestra
of the sea?

The waves
that boom
with the sound
of a drum?

The drops
that get tangled
in the algae
threading
necklaces of salt
with their buzzing?

The fishes'
bubbles?

The deep
silence
of low tide,
the powerful
uproar
of the tide
that builds?

The *cochayuyo's*
whispers
when they comb
their braids?

The seagulls'
echo
when they
break
the waters'
crystalline surface?

Who directs
the orchestra
of the sea?

Translated by Monica Bruno Galmozzi

Irene Bleier Lewenhoff

Jerusalem

City
of stones and cream
that breaks apart and splits.
Penetrated
by fear
and madness
crushed
over the hills
and among the dust
dry bloody dust
dry blood
black and coagulated
without end
without limits
only presences
only nets tied
to walls to stones
to memories and to severed
histories.

Translated by Laura Nakazawa

Irene Bleier Lewenhoff

Café "Habimah," 2/12/94

Today coffee tastes
like a plane,
it tastes like Paris.
The smell
of Montevideo.
But it is from here.
It is from a whole life here.
It is from my whole life here.
To write? In what language?
What I have to say
it is said,
who knows why,
in Spanish.

Translated by Laura Nakazawa

Irene Bleier Lewenhoff

Galilee

A cloud of lies
a broken column
Turkish or Byzantine
amid low trees bushes
stones fragments of stones
and sounds
fifty thousand sounds
flies chickens
turkeys
the bees the dogs
stone walls
that are
the creaking sounds of the forest
the sounds of birds.
When one leaves
once
later always
and forever
keeps leaving.

Translated by Laura Nakazawa

Memory

Sometimes it is
as if everything started in me.
Wide the silence of death
though it may be
enormously heroic
chosen death and therefore
death like any other.
Because each day
that we do not commit suicide
we are choosing some death
and it doesn't matter from what hands it comes
nor at what moment of this history;
and nothing grows from what remains
of the dead
no life algae
spirits and legacies
nor stones or branches

Translated by Laura Nakazawa

II

FULL AS A POMEGRANATE
Yiddish

In Jerusalem, Angels Come

In Jerusalem, angels come
And open the doors of Jewish homes.
They teach the children to love the Torah,
To stay silent in wisdom,
To become breadwinners.

Every day, an angel comes,
Every day, another comes,
Until the awakening of dry bones.

In Jerusalem, angels come
And walk upon the unpaved streets.
They carry sand,
They drag the stones
Alongside poor Jews touched by the divine.

Every day, an angel comes,
Every day, another comes,
Until the awakening of dry bones.

In Jerusalem, angels come
Before the sun comes up,
Before the sun has risen.

They're wearing such garments—
Robes shortened and mended—
The *Shekhinah* illuminates
Their patched-up clothing.

Every day, an angel comes,
Every day, another comes,
Until the awakening of dry bones.

Translated by Katherine Hellerstein

Kadya Molodowsky

Jerusalem

On the mountains of Judea
Exalted is Jerusalem.
Old is Jerusalem.
Young is Jerusalem.
Eternal is Jerusalem.

Year after year, and generation after generation
Jerusalem shines forth.
Night is Jerusalem.
Eternal is Jerusalem.

In the *Siddur*, in the *Makhzor*[1]
Jerusalem strengthens.
Comfort is Jerusalem.
Holiday is Jerusalem.

East, West, North, South
Bow to Jerusalem.
Wisdom is Jerusalem.
Torah is Jerusalem.
Eternal is Jerusalem.

And the shepherd, the king,
Stands and guards Jerusalem.
Blessing is Jerusalem.
Peace is Jerusalem.
Eternal is Jerusalem.

[1]Siddur—the daily and Sabbath prayer book; Makhzor—the High Holiday and festival prayer book.

On the border of infinity
Stands the city of Jerusalem.
Half celestial,
Half earthly,
In conjunction with the royal decree.

Mountain cliffs protect her
White stones recite psalms
Desertlike and fearsome
With the gray beards of giants.

It took a thousand years to get there
And no time at all—
A city stands
Like all cities—
And this is Jerusalem.
I stand in the middle of the city

And long for Jerusalem.
I want to cry—cannot,
Because the rejoicing is great there.
I want to laugh—cannot,
Because the sky recites the afternoon prayer.

A person stands and knows not where,
And all his bones say:
Great, merciful God,
I join you in partnership, I swear.

A God-calmed city, stands Jerusalem.
Burnt—she blossoms in the prayers.
Deserted—the caves guard her,
Hungry peoples come to her to borrow bread,
And the shepherd, the king
Keeps vigil over the crowns

Originally published in Paper Bridges: Selected Poems of Kadya Molodowsky.

Rukhl Fishman

Full as a Pomegranate

I'm full
Not of good deeds
but of appetites,
full as a pomegranate,
and red laughter
is about to spurt
through my skin.

A bee
could lose its buzz
in sheer envy—
all the cells of my heart
brimming
with honey and light
thick, thick
joy
layer after layer.
And I won't measure
or count the treasure
of your face—
just joy
layer after layer.

If I stay this way
one more minute
a window in my blood
will fly open—

"Good morning,"
I'll shout.
One more drop of sunjoy

and the pomegranates will let go too.
What red teeth!
What red catastrophe!

613 sweet sins
613 luscious joys
for both of us
I gather
as I gather the fruit.

Bet-Alfa, September 1960
Translated by Katherine Hellerstein

Rukhl Fishman

In the Beginning

In the beginning
was the sun.
The valley
is the sun's dimple.
All pomegranates her breasts,
all grapes
her fingertips.
Her toenails,
thistles in the field.
the bones of her raised fist—
Mount Gilboa.

When the sun undoes her braids
and her black hair
spreads over her pillow,
night comes.
But we know—
her pink ear
pushing out of the covers
is dawn,
the beginning again.

Translated by Katherine Hellerstein

Rukhl Fishman

What Do I Do?

1

What do I do
when I don't know
what to do?

I swing like a monkey
from one question mark
to another

and hang there—
ugly,
wrinkled,
ridiculous—
facing myself
and you.

2

Oh no
I'll
soon
be old

I won't button
my coat

I go out on the street
I have a red coat
I'm cold

Oh no

I'm growing old!

I didn't listen to you.

3

All
Or nothing!

But often I'm left
with a full heart
and empty hands.
And so I have both
all *and* nothing.

Sober-drunk.
Openeyed-blind.

4

Hoarse—
from keeping silent
from waiting
from half-words,

I hooted like an owl
out of the blue,
sobbing like an owl
in the dense wordforest.

Translated by Katherine Hellerstein

After a Visit to Israel

See,
How we write your name
In Yiddish, in English,
In sign language,
Write to you
And send out the letters of the alphabet
Like letters flowering
From bonfires,
Destruction,
From souls with love
We inscribe in you
Our destiny
That wants no longer to bleed,
But wants to blossom,
To continue its blossoming

Translated by Katherine Hellerstein

Rivke Basman

Doves

Doves, too, are Jews.
Otherwise would not
The road lead them
Back to build their burned-out nest,
Back there,
Where even the threads of their nest
Were destroyed.
Don't doves also have
A Jewish memory?

I've always known
That the cooing of a dove
Is
Yiddish.

Translated by Katherine Hellerstein

Hadassah Rubin

Untitled

I don't have any other words,
And now new tears.
The blood on the streets of the world is blood.

How will these very words,
My wept tears,
How will they stop the hand
With the ax?

God, I speak
And don't know to whom.

Sadness, I say to myself,
Hard stone.
How will I lean my life against it?

Translated by Katherine Hellerstein

Untitled

In those places there are no birds.
In those places, the dew falls, belated
And stingy.
There, one person fears another
And kills.

The birds flee and take with them
Whatever they have—
The melody of their singing.
Nests remain without song,
And branches—without nests.
No, I have not forgotten. How could I forget,
That in every place once song-filled,
Children do not know that they are children?
They dream dreams
Hungry and terrible dreams,
Without birdsong, without children's laughter.

Because in that place the dew falls, belated
And stingy.
There, one person fears another
And kills.

Translated by Katherine Hellerstein

Untitled

On the new street
Where I have come to live
No one calls me by name.
I am afraid
That perhaps I will always walk, lost
Without a name
On the new street.

I am afraid
That perhaps I did not arrive,
But stopped next to a tree,
Next to a door, an open door,
Next to a remnant of dreams.

I am afraid
I myself shall forget
In this new, strange alley
Without a name
How to find the way to myself.

Translated by Katherine Hellerstein

III

A DRESS OF FIRE
Hebrew

To My Parents, of Blessed Memory

I don't know you
to tell the truth
you don't know me either.

I see barbed wire rusting in your eyes
in the evening when your soul hollows
opposite the television console,
in your arms a small tuna salad
together with dry toast

but your mother tongue is not my mother tongue
so we prefer to take a walk:
walking is better than sitting,
sitting is better than lying down,
lying down is better than sleeping

and we walk,
your arm linked in mine,
and we play
"once upon a time"
that I was your mother
and now you are mine.

Translated by Lisa Katz

Monday

So what have we got?
The sweet scent of jasmine,
the drawing of an orange sun
discovered suddenly
while cutting the persimmon in half
at the first volley of light.
the chicory flowers'
morning blue,
the entire meadow,
a cluster of snails
on top of a sea onion stalk
and there was also the word "wagtail."
What else was there?
The cicada requiem,
pink sheep in the sloping sky,
and the soft, much-kissed down
on the bottom of the cat's ear
and that's it, I think
that's what we had
today.

Translated by Lisa Katz

Woman Martyr

You are only twenty
and your first pregnancy is a bomb.
Under your broad skirt you are pregnant with dynamite
and metal shavings. This is how you walk in the market,
ticking among the people, you, Andaleeb Takatkah.

Someone loosened the screws in your head
and launched you toward the city;
even though you come from Bethlehem,
the Home of Bread, you chose a bakery.
And there you pulled the trigger out of yourself,
and together with Sabbath loaves,
sesame and poppy seed,
you flung yourself into the sky.

Together with Rebecca Fink you flew up
with Yelena Konre'ev from the Caucasus
and Nissim Cohen from Afghanistan
and Suhila Houshy from Iran
and two Chinese you swept along
to death.

Since then, other matters
have obscured your story,
about which I speak all the time
without having anything to say.

Translated by Lisa Katz

Hava Pinhas Cohen

And Abraham Awoke Early

And Abraham awoke early.
He didn't know he was walking in the Jerusalem hills
the sun still close to the hills of Moab
and the rocky ground painted red gold
and a cold daring Nachshon wind between the autumn winds
touching my bones and shriveling my skin.

I hid narcissus and anemone bulbs in the earth that
remained between the rocks
I sowed winter vegetables and greens for soup
unlike my father, I didn't plant fruit trees or pine trees
or pomegranate or orange not even olive
carefully, carefully
I sowed only those that would hurry to return my love
to me.

From The Color Mostly, *1990*
Translated by Linda Zisquit

Tractate Women

I ask you to buy me earrings of a blue
close to green and quarried from the sea and time
buy and bring me earrings, two drops of blue
I ask for it to be a pipeline of love
that connects and delivers and has pity
and have something hanging and dangling. An object to testify that
you stretched your
hand out
to my hand naked of any watch
and I extended my hand before me—
and you placed inside it a pair of earrings of a blue close
to green that will protect us from everything.

From A River and Forgetfulness, 1998
Translated by Linda Zisquit

Golem

I purified myself
and put on my bridal gown
my hair I pulled under the kerchief
and I turned like this and like this
and saw nobody who wanted my soul or
the underside of my arms

I started from the beginning.
Went south to the edge
between land and sea, to Ashdod
and a broom-studded virgin dune
and mixed its dust with fresh water
I brought in my pockets
and added my children's milk
when my breasts filled.

I squatted and strained
and wrung my hands
and curved my arms
and kneaded the dust on my belly
and twice over on my thigh.
And limb by limb I whispered
my mothers', grandmothers'
and daughters' daughters'
beautiful names, adding versions:
Sterina, Bouca, Allegria, Regina
Rebecca, Sarika, Rachelika, Sofka
Fika, Milka – a mother for each
and every limb and organ.

I squatted like a birthing mother

gazed into the glinting sky
until the figure of a nameless daughter
stood before me and I kneeled
and kissed her thin lips
and ripped my bridal gown and dressed
her innocent nakedness.

Since that day my sheets fill with sand
and my golden daughter with breasts
creates shapes inside me and pleads:
'Oh ah ay ee oh ah aah
Madre mia mia querida
Dis mi Dis un poco di agua
Que di sidar y no di hembri
El dio ya vio dar la alma'

From Orphea's Poems.
Translated by Riva Rubin

Yonna Wallach

A Different Bourgeois

A bourgeois pervert
just to spite will kiss in the church of the Holy Sepulcher
with premeditated intention
out of
an irresistible
impulse
deliberately
according to a prearranged
scheme
he'll make a production of himself
to spoil in the same way
the title of the bourgeoisie
to disfigure its face
always
till the bitter anti-bourgeois end as it were
except for extraordinary cases
that someone set up for him
a sweeter end
like a doll in someone else's arms
with a doll-like mechanical look
on purpose
or not on purpose—
or not on purpose

Translated by Linda Zisquit

To Kidnap in the Land

I kidnap children in case the parents object
I also kidnap parents I kidnap women
in case the husbands object I also kidnap husbands
so no one is separated from the natural environment
but young men how they seem ready
for landscape for luxury youth are like mistresses
gliders possibilities and all that is in youth
I kidnap like only I know how to kidnap.
I don't kidnap in the old style. (In my opinion) you need to ignore
to not even know where they live in order to pull off
an acceptable kidnapping here, (strictly between us) there are no
forests here
in the woods of the Jewish National Fund one only has to think
 twice
and already he finds himself on a Sabbath outing.
Memories rumors, maybe I'm not built for this
but when I hear the news the wind goes out of my sails
and the people kidnapped are not afraid. The Voice of Israel calms
 everywhere.
In the Negev it's possible to kidnap youth in the middle of the day
bright light but where do you see youth there.
At the start I take note of unexpected buildings
Negev youth are protected and walk around surrounded by
 kidnappers of youth.
And that's why I don't base my pleasure on fear these days I give up
whoever I kidnap doesn't know and I'm like that hidden pleasures
(not only that) I kidnap and I pretend.

Translated by Linda Zisquit

Yonna Wallach

The House Is Empty

The house is empty and the trough broken
and Naomi who my soul loved where
did she go. The house is robbed, the cupboards
empty. And Naomi is on her terror way
what embroidery or shreds of embroidery
for her body. The orchards are dry, land
abandoned. Weeds, nettles.
She-asses don't trample loose dirt
and Naomi doesn't beat she-asses.
Naomi who my soul loved. Water-
fowl and life and Naomi where
is a virgin, and who won't revive her and if only
Naomi saw life in her days
and would yet call up joy in the meadow.

Translated by Linda Zisquit

Michal Govrin

At the Close of Time

On the Sabbath before Rosh Hashanah
At the close of time
Before it opens forth again
Unsure
We are immured in straits
Dire as judgment, blind
And absolute

On the Sabbath before Rosh Hashanah
Not the Sabbath of Return, not "By your might"
For of what use in your sight is all our striving
If not to disclose these crimps of
The soul, to recall them
Like a dove that finds
A moment's respite in the cleft

On the Sabbath before Rosh Hashanah
In this city clamped
Like an ant-infested
Orange rind
Cast into the dust heap where the
Cats of devastation prowl
On the night of the mantled moon

On the Sabbath before Rosh Hashanah
The city unfolds like the draper's shop
In creases of the shaded alleyways
And the stairs we climbed to the rooftop
When a tingling whiteness flowed
From belfry towers
So close to the sky

Still our feet shall stand before you
Unsounded polyglot of many faces,
You who watch as we tread the flagstones,
You to whom all words flow—
Even the orange-vendor drawing near
Breaks into a smile
Before the pen that
Draws us both together
If only for a moment
In your alphabet

Translated by the author

Michal Govrin

Like Ravished Women with Severed Tongues and Hands

In those days when the city was torn again right out of the verses
 of Lamentations
Not by the voices issuing from the *shtebels* on the eve of destruction
But by blood and corpses, and weeping of hard-faced men
And missile-fire over Bethlehem, the screaming of mothers there,
And the din of planes in the dark of night demolishing our mutual
 slumber

In those days when the city was püking its guts out
When blood from the altars of the Valley of Hinom flowed over
Aceldama,
At dawn, pillars of smoke would raise the stench to heaven
At sunset the smell of scorching would ascend on high,
Stinking through the shattered night

Only the Minister of Hatred, raving in a trance that flickered till
 morn,
Floated over the *suq* and the men sitting
In their shop fronts, shrunken, limp,
Then swooped down on a scattering of worshippers at the Wall,
 and circled
Sardonically, reeking of spring
over the hills that knew so much and still kept their counsel—
Like ravished women with severed tongues and hands.

Translated by the author

Michal Govrin

Who's Afraid of Jerusalem

Who's afraid of Jerusalem?
Who loathes and despises her?
Who execrates her, heart and tongue?
Who says, What am I doing in this city of black hats
And maniacs
This city of blood and enmity
Where Hillel the Elder pursues peace
Amid the broken cups and carnage?

Who hates Jerusalem
For the love wherewith he loved her once in secret
Courtyard shadows of the vine
Twilight, jasmine blue?

How cruel is the hatred of Jerusalem
A very flame
Many waters cannot quench it.

After the terrorist attack at Café Hillel in September 2003.

Translated by the author

King Solomon Who Remained in the Language of the Animals and Fowl

King Solomon who remained in the language of the animals and fowl
and forgot the language of man
would sit mourning in the lap of the Shulamite
and.with lowing ask that his tongue return.
The Shulamite, her hair coarse and disheveled,
scratched his beard with her little finger
sinking into his lowing
"Oh parrot, oh leopard, oh cricket,"
she'd whisper to him,
mixing in the language of the animals
afraid he'd remember.
King Solomon lying on his back
bleating like a lamb
braying like a donkey,
and the Shulamite takes off her clothes.

Translated by Linda Zisquit

Noah

Noah installed wheels on his ark
dragging it after him
in case the flood suddenly returned.
Grapevines, noticing fins at his temples
and shiny scales at the opening of his shirt,
turned into raisins, dried out their juices
to ease his fear of their drowning wetness.
Noah installed wheels on his ark
and when children hung from its side-poles for a ride
Noah lovingly offered them
brittle clods of Ararat.

Translated by Linda Zisquit

The Song to Jacob Who Moved the Stone from the Mouth of the Well

He didn't know I was Leah
and I—I was Leah.
Rachel, he said, Rachel, like a lamb
the grass becomes part of, stems are a part of you.
Flocks of sheep hummed beneath our blankets,
tent-flies were pulled to the wind.
Rachel, he said, Rachel—
and my eyes were weak,
the bottom of a dark swamp.
The whites of his eyes melted
to the whites of my eyes.
The cords of his tent held fast to the ground
while the wind was blowing from the palms of my hands.

And he didn't know I was Leah
and flocks of sons broke through my womb to his hands.

Translated by Linda Zisquit

Sabina Messeg

And the sea

And the sea
as always
is a miracle
that does not dry up

Blue not deep not strong
that still overpowers
my days

Again I have come
placed myself before it
awaiting its murmuring

Translated by Karen Alkalay-Gut

Before Life Starts to Quiver

Before life starts to quiver
like a fish with his intestines out
but not his life—
his life is still within—
there is more life to him—
there is a white sea that is still his own—
the depths are still deep
from him
alone

Before life starts to quiver

let's linger a bit more
facing radiant scales

Though the knife blade is reflected there
as well.

Translated by Karen Alkalay-Gut

Experience

How many wars have we seen?

I mean the ones that seared us
on the news, in the papers,
the wide screen, the water cooler
as well as those that hovered
over our heads, gnawed at the door,
made only our blankets seem
a safe cover.

When I think of
what our eyes have seen,
our ears have heard
It is no wonder
we can't even dream
of peace as more than

an easy word.

Translated by Karen Alkalay-Gut

The Voyager: Bull's Blood

Sangre de toro[1] still runs in my veins
as gray morning starts to shed light
on objects in the room,
restoring their shape
while leaving their strangeness intact.
My head is giddy as if all night long
it had been swung
towards a cheering crowd,
my hand gropes for
the name of the city beyond the window
and I don't need to open my eyes
to know
that the bulk on the armchair
isn't really the heap of my clothes
but the image of you,
almost in flesh,
and soon you'll incarnate in the light—
a midday light
from another time and place—
erase the last traces of my dream
and with a soft voice,
more suited to mercy,
reproach me
for having drunk so much
and right away forgive.

Translated by Vivian Eden

[1]*Sangre de toro:* "bull's blood," a Spanish wine

The Voyager: Foreign Language

Again I'm trapped in the claws
of the most oppressive loneliness:
sentenced to wakefulness among the sleeping.
My gaping eyes
stare at nothing.
Where is the merciful memory
that would dull the chill of the hours
heaped till the first bluish light?
Where is the morning?
Now I shift to the irreparable time
of the dead, that gathers outside of time.
The voices of the living drift to me in ragged flakes
as if swept from the far end of a corridor.
They lack any sense. They leave me untouched.
I speak a foreign language.

Translated by Vivian Eden

The Voyager: Into the Garden

If only I could enter this city today
like I followed you down into the garden
—In Greece? In Italy?
stunned by the bright-dark-white
imprinted on your nape
by leaves of trees whose name I never knew
though I'll never forget their shadowlight—
like I entered the garden with you that morning
for an Italian breakfast, or maybe Greek, who
cares, I cared only
for your lips that bounded
an abundance that the rest of your body avoided—
like I soared towards the branches with your words
that wavered and sounded like questions
for you didn't trust your accent—
yes, to be fettered like that, with bliss,
while leaving behind all other chains
if only I could once again—
then there wouldn't be such insult
in this city that greets me with its rude noon,
and the beige of the bedspread,
multiplied in two hundred rooms,
wouldn't stretch from the bed to the opening door
like a slap on the cheek
to awaken impatiently
he who dreamt too long.

Translated by Vivian Eden

Dahlia Ravikovitch

A Dress of Fire

You know, she said, they made you
a dress of fire.
Remember how Jason's wife burned in her dress?
It was Medea, she said, Medea did that to her.
You've got to be careful, she said,
they made you a dress that glows
like an ember, that burns like coals.

Are you going to wear it, she said, don't wear it.
It's not the wind whistling, it's the poison
seeping in.
You're not even a princess, what can you do to Medea?
Can't you tell one sound from another, she said,
it's not the wind whistling.

Remember, I told her, that time when I was six?
They shampooed my hair and I went out into the street.
The smell of shampoo trailed me like a cloud.
Then I got sick from the wind and the rain.
I didn't know a thing about reading Greek tragedies,
but the smell of the perfume spread
and I was very sick.
Now I can see it's an unnatural perfume.

What will happen to you now, she said,
they made you a burning dress.
They made me a burning dress, I said. I know.
So why are you standing there, she said,
you've got to be careful.
You know what a burning dress is, don't you?

I know, I said, but I don't know
how to be careful.
The smell of that perfume confuses me.
I said to her, No one has to agree with me,
I don't believe in Greek tragedies.

But the dress, she said, the dress is on fire.
What are you saying, I shouted,
what are you saying?
I'm not wearing a dress at all,
what's burning is me.

Translated by Chana Bloch

A Great Tremor

When the bells tolled, when the muezzin wailed
and the rooster protested against the moon,
a great tremor seized Jerusalem
and the King's palace
lit up the streets.

In Solomon's stables
monkeys and parrots shrieked,
the ones Queen Tahpenes sent him
by merchants and highwaymen.

The still waters of Shiloah gathered to a cataract,
roaring into the Valley of Hinnom,
shattering
in the clefts of rock.

In Solomon's stables,
princes would serve for a daily wage
until the King wished to harness his chariot.

When the bells tolled, when the muezzin wailed,
two border guards took to bed,
cursing.
On a cloud black as a Negro's hand,
Jerusalem the City of David was hurled away
like a finger torn from the body.

Translated by Chana Bloch

Dahlia Ravikovitch

On the Attitude Toward Children In Wartime

He who destroys thirty children,
it's as if he had destroyed three hundred,
and infants too,
and eight-and-a-half-year-olds.
(In a year, God willing, they'll be soldiers
in the Palestine Liberation Army.)

Ignorant children, they don't even have
a real world view.
And anyway, their future is shrouded:
refugee shacks, unwashed faces,
open sewers in the streets,
infected eyes.
A negative outlook on life.

And then begins the flight from city to village,
from village to burrows in the hills.
As when a man runs away from a lion,
as when a man runs away from a bear,
from a cannon, from an airplane, runs away
from our troops.

He who destroys thirty children,
it's as if he had destroyed one thousand and thirty,
or one thousand and seventy,
thousand upon thousand.
And because of that, he shall find
no rest.

Translated by Chana Bloch

An Expert

I'm an expert
At losing

Once I exchanged an ocean for a distant mountain a mountain
for a whole desert a desert for a brief love of a man
him for hope hope for a bird close to my heart

Deer flit by in Habima Square at midnight
morning dew proves a true essence of chase

If I'll desire the softness of water
I have nothing to exchange

Translated by the author

Pnina Amit

Fractures

Mother

You don't have a beginning, said
my mother, you
came from the darkness.
I am
Your darkness.

Father

They said: she is like him.
Doesn't laugh doesn't cry eats and sips
sparingly bread and water. Cannot
love. Closed
and sealed in pain.

Only
when you said, before you died, my child
you
are not
like me

I believed them

Translated by the author

Yehudit Ben-Zvi Heller

In A Foreign Country
For Maayan and Adi

Dawn after dawn my mother—
a fanatic to *Let the air in Let the air in*—
opened my childhood windows
and spread the linen on the sills for the sun to kiss.

At Hayarkon Springs, like the eucalyptus grove planted there a
century ago, I found my adolescence
clearly mapped: These were its boundaries:
the widening fields—their smell of midnight bonfires, in their
furrows the dampness
left by the dawn and sprinklers;
the train ties—veins that pulsed with our walking
between the rails—the Hifa-Jerusalem line with a stop
at the Opening of Hope;[1]
and the broken walls of a Roman fortress with embrasures
whereby mystery became safety: we could see without being seen.

And Snow White getting lost? That was strange to me.
Just as puzzling: Red Riding Hood swallowed by the wolf.
Who heard of the eucalyptus shading wolves,
and could anyone be lost in a grove?

But here windows are kept closed in winter.
And here even in the summer it rains.
Here the sun does not soften the sheets and the laundry
does not dry in the wind.
Here the forest trees seem like shadows of men, here
the forest does not wonder—these are not my trees,

[1] *Opening of Hope is the name of my hometown (in Hebrew: Petakh-Tikva).*

79

for here the evening descends early on my house,
and as if possessed, in sudden fear,
I draw curtains thickly over my windows.

From Kan Gam Bakayitz Hageshem Yored (Here, Even in the
Summer It Rains)

Translated by Agha Shahid Ali with Yehudit Ben-Zvi Heller

Yehudit Ben-Zvi Heller

On the Road to Your Mother's Funeral
For Christine Stevens

Your pain is my fear. I awaken to it
while winter stretches white over the moving landscape.
I reflect you, like a pane. I see you inside me

sitting low,
your neck in knots as you look up. In your eyes
so many salt rains. They bring the smell of the sea.

Not enough salt on the road,
a man says. He is driving me through a world that goes on
behind my closed eyes,

thoughts curling there like smoke, for hours,
ring after ring—like trains rushing
over rails that, never moving, let it move

through rushed landscapes, again and again
with an ever new cargo.
Your fear already

has moved you to other destinations.
Your direction is clear, black rails
over the earth's ever-whitened face. And what is unfamiliar?

The spaces stretching, drawing out dark behind you, opening
to the falling evening,
falling fast like the cold.

Translated by Agha Shahid Ali and Yehudit Ben-Zvi Heller (with Adi Heller)

Maya Bejarano

A Minute Garden of Eden

A minute Garden of Eden in the recess of my head,
so identified during a hurried drive, through the quite heavy traffic,
toward a specific location in town, more precisely,
outside town, but not too far beyond it.
What was it that in such a minute space of time
flickered like a pulse of light from dim distances—
a beam of thought that binds all particles of my being,
no pain getting in the way, just the complete body,
seated, relaxed, absorbing the simple shifting of gears
on a rain-soaked thoroughfare
on either side tidy flowers and intra-city lawns
signs testifying to the known identity of place
and yet—not a negligible everyday detail
underneath the surface your attention is drawn inward
as you maneuver the profusion of overpasses,
the route as basic as the specific destination—
not for me, but for the dear one I am driving.
Briefly, a new vision forms,
a glance into my innermost that has fallen from my eyes
to the hidden satisfying place identified
as my inviolable Garden of Eden
my own Garden of Eden
secreted and found.

Translated by Zippi Keller

Maya Bejarano

Falling In Love With Myself Through Another

Tonight her eyes flashed with the spark
of sapphires toward me
but before I made note of it
I lingered in her spell
as she recited my poem in her voice—
naturally, in whose voice she could have read
the poem if not her own?
Perhaps another's voice joined hers,
magnifying the sparkling allure of her glance
as she read my poem
the dark green dress enveloping her
stirring like sea velvet
enhancing her charm.
I said velvet, let me add foam
ascribed to the delectable glow of her cheek
fused with the stinging saltiness of sea froth
sickening and healing at once
and the scent of dense grasses
from a distant land.

I know that when the night ends—
I'll kiss her.

Translated by Zippi Keller

Liat Kaplan

Fantasy

The apartment will be private: air empty and pure of other breaths
will flow through my lungs. No cup will move from where it was put.
Flooring, walls and thoughts will be free of decoration.
No phone will ring, no fax print, no newspaper set down. Silence
will reign. No muscle will jump fearing penetration. Three corners
I will create in my symmetrical house: I, I and I. Ninety degrees
precisely between each and its sister. At dusk thought

moths will glide through the calm, a silent winging
will row through space. Colors of metal will limn the dimness
hexagons will dangle from lashes. Ravaging peepholes
will flash their wings to bite me

My gates will open slowly
My hand will write nothing.

From Tzel tzippor
Translated by Vivian Eden

Liat Kaplan

Alina Goes Up

In the elevator in Assuta Hospital I go down and up don't hear
anything don't wanna already five years holding Teddy hard reach
the button fine go down and up I wish she'd hurry up and die I don't
wanna hear. I turned around and ran, my legs ran, it was white all the
time and lots of hallways. Her voice and the smell of BM and cheese
and missingness caught up with me by the elevator. I'm sure not gonna
kiss her. She's dead maybe, I already smelled it before. Pajamas all the
time without her dresses and perfume and high heels, only the pearl
earrings not my mother really.

And right after that they sent me to a kibbutz
and said Mommy's gone to America again,
the land of unlimited possibilities, there
death scraps the skies, I traveled there to kiss
her, blind from betrayal, going up and down
all Manhattan's elevators. Her death stinking
sticky dark and her voice in the smell of cheese
feces reaches me, strangles, longs.
Now here I am speaking.
I stop.
I say:
Enough. Enough. Now Alina goes up.

From Bediyyuq kakh, ba-mitbax
Translated by Vivian Eden

Haviva Pedaya

Untitled

when I come from the Place of Crying
the pitied the deceased
and in life absent
when I come when his hand shakes me
at night he diverted his light entirely
and the tree's verdure was purified in him from within
concealed between his wings a bird so black
the crickets are heard the buses desist
that moment I opened the walls
and the heavens blew into rooms
I call you now to answer me
despite my prayer's silence in the morning
despite the moth's presence in my closet
despite my fullness with rusted talk
as I feel as you shake me as I rise
as I was my own enemy
when I come from the Place of Crying
I will come in lasting bliss
the pitied the deceased and her life yet alive
I will sparkle from the tears
and I will emerge I will not wonder yet that my day is so
dark for I far from discriminating
among all the kinds of precious darkness
for I still understand nothing about the illuminated light
I will thank you then for the orange beak
birth-giver of the sun with its song.

From Mi-teva stuma (*A Sealed Ark*)
Translated by Harvey Bock

Haviva Pedaya

Untitled

one who speaks to the absent
how deep his conversation
he sings for the benefit of one
who is completely oblivious that he exists
he exposes himself in his nakedness
to one who does not look
how entranced the listeners
by this divine music
not knowing that it was not intended for their ears and not
grasping that this is merely its echo
it is the magnificent speaker
who gives them birth
his mouth in the dust
his soul trickling inward as it expires
he recites the blessing over slaughter
restrains the flow
the constant lover
is never loved
in his dream he is remembered
and when he opens his eyes
no one comes
one who speaks of the absent
his nature nothingness
he sits alone in the gloom and sings
and when the darkness stirs
he is not rushed

From Mi-teva stuma (*A Sealed Ark*)
Translated by Harvey Bock

Untitled

please with gentleness
please with forcefulness
release my bound soul
please I need longing and sighing
more than what exists
may I yearn
and nothing come
but may I not stop asking
please give me words you once gave me pure
and I will say
please have pity
today today and not tomorrow
please declare that even if I tarry
I will surely come
and I will place myself in things please
remember me
for having wished you for me and for not
for my being a person and dead
for a soul's striking the body's walls
wishing to be uprooted
striking itself crying
please blessed one
please bless please
understand me for I am barren
for I have no one to whom to reveal my sickness
for I did not understand in time that my body is me
and when I understood I did not know my soul
I found no outlet for my crying when it strikes
as there isn't
please understand me for I need some time
to calculate the chances of flowering

whether it will be more devastated
and I wither from terror
and vomit every morning
one thing I have asked and it I seek
your dwelling in me your giving me a spirit
one thing I cried when I remembered myself
for then when I prayed I lacked nothing
and now that I desire nothing
everything is trampled in me please be gracious to me and pity
bless my days purify them
raise them like a daughter crying over the apple of her eye
please if you can

From Mi-teva stuma *(A Sealed Ark)*
Translated by Harvey Bock

Hedva Harechavi

Pleasant Senses

There a magnificent assembly of dogs and here is a bird
dripping with blood that already remembers
every possible detail

My observation point learns a lesson:
it is possible to hire a killer
in exchange for an envelope

Now one ideal is entirely shattered
a second ideal is eliminated
from panic

Small death observes me with eyes of small death
as only small death can
observe

On the path which leads to the Garden of Eden so I was shaken
to hear red views from every direction
passing in silence

Red views in my head is it red views in your head?
Someone coming toward me is it someone coming toward you?
A completely black dog around me is it a completely black dog
around you?

I know what it means to put a white footstool
on 1000 dunam of fantasies
and to see nothing on a piece of paper and to draw

Where, where are you sleeping tonight, Ruth,
and who will play in your place
on the trumpet?

Translated by Linda Zisquit

Hedva Harechavi

And This the Rarity

And this the rarity	to listen to his breaths
And this the rarity	to place wreathes around his wishes
And this the rarity	and to explain to him love peace longings
And this the rarity	because this evening a choir of angels
	will sing in his home
And this the rarity	as though he is made of a different substance
And this the rarity	(hard for me to imagine)
And this the rarity	and to concede, to concede to him, to
	concede
And this the rarity	just to say his name out loud
And this the rarity	to give him a slip of paper and a pencil
And this the rarity	to unburden him of his worries
And this the rarity	to take his shoes off
And this the rarity	to hold his understanding hand
	when his eyes close, his eyes

And this the rarity, that is my child, only my child,
then God
and His companions

Translated by Vivian Eden

Hedva Harechavi

His Face

My son is silent often
contemplating without eyes
skies that will never again pass
above his face

Translated by Vivian Eden

Nurit Zarchi

Weasel

You tell me what I don't know
That's obvious to one and all and I'll know I exist
like the same day-blind weasel hungered by night
which crosses the road like a wave its shadow even longer than itself
she'll rear up on the precipice and for a few minutes
defy gravity, her nostrils dilating in the wind
her pinched nipples exposed and then she'll drop back down
onto her haunches following the dark snout
(if she's not run over) to disappear under the grove's roots
and you—you sense you've seen a ghost or a shadow of your own
 absence
although she's disappeared from the undergrowth
you'll still hear her voice grumbling *oink, oink* above the summits of
 pine trees and chimneys
evening stretches the sun's shoulders in pink chemical gardens
seeing her, the Romans also felt the same disgust-arousing excitement
Sardius, they called her, which means artisan
perhaps because of her fingered palms for washing her food,
in Celtic, the mask in which the Thessalonian witch appears
and in Welsh, the art of inspiration—mainly poetry
the self-same art which never finds its niche
perhaps hasn't a niche at all since when it's required is before or
 after writing
it's just the writer dragged along harnessed to the weasel's carriage
defined as an assumed flower which memory grafts onto a stem or skull
slighty off the neck where the image lies in relation to reality
leaning like the Tower of Pisa and if the heart's in the right place
it's no wonder we'll find it insincere, fraudulent even
trying to compete accurately with life's own terrors
at the same time as offering comfort

in her cunning claiming it's not weakness
but rather her strength that she doesn't rely upon reality
like the earth rests against the moon in an eclipse
but leaves us with the narrow path between darkness and light,
where we'll blindly seek out prey exposed to harm from sorrow,
 pathos and greed
and all just to show ourselves we aren't trammeled by reality
but were for a brief moment (I'll make do with this)
too close or too distant—a living soul.

Translated by Lisa Katz

Nurit Zarchi

Forgive Me for Bursting Out

Forgive me for bursting out
I think I was shot at, Sir.
I am completely mistaken to rely on love,

but who talks about precision
while women and children are being killed?
And don't take it to heart you say.

More than once I keep from dozing off
my eyes wide open like the wild pigeon
on the windowsill that laid me an egg

and the next day nothing not even fragments,
vanished like starlight
without a single message for me.
I should have understood

why you shot me, Sir: that another dream won't bother us
again on the way to sleep

Translated by Lisa Katz

For there is in scent entrance to love

For there is in scent entrance
to love
to flame
and to tranquillity

and there is in scent entrance
to intoxication
to memory

to dreaming
to compassion
and to rejuvenation

to wisdom
to flight
and to soaring

into marriage
with incantation
into the brain flow of meditation
secretly

for there is in scent entrance
to love
to passion
to the aroma of perfumes
to odors

and in pounding of the heart

in lavender

in rosemary
in people
in jasmine

And there is in scent great prelude
to the caress of winds which touch the angels

And in scent there is entrance
to transmigration
to greatness
to power

for in scent there is entrance
to prophecy
to the Sabbath
And to the hastened pulse

for there is great prelude in scent
in yearning
and in healing for the willing soul
in longing
in joy
and in the beginning

for there is in scent entrance
to delusion
to predicting

to mating
to change
to exaltation

For there is in scent great heralding of the Celestial chariot

And in scent a grand entrance
to poems
to wonders

to flowering
to purity

to truth
to life
to the soul

And in scent there is great prelude to spirits

For the scent is the kiss of being

From For there is in scent entrance to love
Translated by Shira Twersky-Cassel

How can I pour words

What I was up above

I stripped the heavenly body like a dress

my soul remained a melody in its nakedness

how much heaven I flowed, I have no numbers

the pleasure of the white wind

and I have no desire and they were completed

the heights of godliness

mounds of psalms cannot

heavenly music

I fell so much in love

God's deep beauty

From The Wind and the Blood
Translated by Linda Zisquit

Ilana Hornung-Shahaf

Desert Dreams

*

I am painting a desert.
Dumbstruck, I try to cover its vastness
In words.
I touch
A soft stone
Devoid of green
Gray, white, brown.
The scorching noon sun,
The purple chill
Of night,
The towering, lonely
Mountain peaks.

My legs tremble.

Translated by the author

Ilana Hornung-Shahaf

Ein-Akev [1]

On a winter day
Strolling towards a desert spring
An obscure pond
Like a gaping mouth
Awaits her.

She undresses,
Water almost frozen,
Trembling as
Algaes whisper her name
In surprise
Caressing her

Breathless
Stirring ancient depths
Of embracing arms
Like a wreath
Upon her head.

Of the road.

Translated by the author

[1] *Ein Akev: A spring in the Negev desert of southern Israel. Akev is the footprint of the Leopard.*

Ilana Hornung-Shahaf

Untitled

*

Dawn
Slowly climbing the mountain.
Like a man of the desert
Tall and bent,
Hands in his coat pockets
Lifting the morning
And the loneliness

Translated by the author

IV

A PEOPLE OF OLIVES
Arabic

Fadwa Tuqan

I Found It

I can't read or speak
Arabic
that fact
makes it difficult to navigate
these lands
and these people
how much can I really hope
to know, to learn,
to feel if I can't be touched
by the mother tongue? Am I bound
to "remain on the surface" touching nothing?

Translated by Saadi Simawe

Enough For Me

Enough for me to die on her earth
be buried in her
to melt and vanish into her soil
then sprout forth as a flower
played with by a child from my country.
Enough for me to remain
in my country's embrace
to be in her close as a handful of dust
a sprig of grass
a flower.

Translated by Saadi Simawe

Between Incarnation and Emptiness

Yearning is a gazelle emerging from its hideout.
It entices me across the dunes.
It takes me to the capital of self.
You follow along riding the horses of wind, rain, night, sun and
 colour,
fused with the atoms of the universe.
You travel your road into my eye,
flowing into my veins.
As you step into my textures
your incarnation becomes complete
and I am you.
But when I reach for you
I touch only the crawling, icy pole
enfolded and empty with silence.

Translated by Saadi Simawe and Ellen Doré Watson

Siham Daoud

I Adhere The Letters To My Lips

1.
I knew exile between my fingers
because every evening I read Álvarez's poems
sipping soup in his company
stamping his kiss on my hanging rope
They seized all my wheat stems
and I press the roots to my breast
The fragrance of jasmine lighting my fingertips
lights the call of history in the loneliness of exile.

Our poets and all those coffeehouse-goers—
what do they talk about?
about Jesus' crucifixion
or about Saladin?

And every day another Jesus is crucified
and every day another Saladin dies.
The tragedy reaches my fingers
and I adhere to the letters of my lips
and my tongues—a congestion of stories and pain.
Come and take me, birds of life
so we can share life, migration, and the map.
True man, lover of truth, where are you?

On the borders
in the coffeehouses
or in the city libraries?

2.
You nations, homebodies, I know
the migration season ended and distances returned

and that twilight is the twin of the hanging rope
and that the children's fingers are not mute
and that for their sake the walls shall bloom with paintings
of the face of disaster,
the face of truth.

My people, my whole life I'll stare at the dark walls
and at the long history of earth
and I'll reside in the disaster in the bosom of children
and the palms of liberty.

I repressed the feast and covenants and the memories
into the eyes of this noble earth
so that men and children wandering times would return
to the corpse of this land
in order to flood our palms with the flowers of our distant Eden
and flood our galleries with unconcealed paintings
and life without estrangement,

3.
The souls of the children were torn in my blood,
my letters drowned, so did my secrets
and the song of the birds—in the language of my song.
On the necks of the birds we read
about the infidelity of time.
The peoples' eyes will be a harbor if no port remains.
O my land, I see my voice like a cycle of seasons
as a memory that swells in children.
And I see the letters of the alphabet
as borders without darkness without tremors,
like the charter of time that teaches map-reading
and the memorial prayer for the souls of liberty.

I gave my body a name: motherland and crater of the world,
and to the history of my people: questions pecking
 my forehead.
And my memory was lost amidst my people—
miracle of generation that started without my knowing it

and in it the buried faces got lost in the valley.

My birds were killed
so the mountain would have a proud slope,
a flag for the end of disaster.

And from my body you snatch the songs of my country
and the halo from my hymns.

Translated by Linda Zisquit

Siham Daoud

I Love in White Ink

In an evening without appointment, without timing
memory rises from my forehead
smuggled, from prison to prison
scattered like the wind of my country
My breath flees beneath my embroidered shawl
in white ink
with the smuggled songs
and its color, don't ask, like the vine, like the wine!
and when the snow fell from my face
I wanted to leave him
I searched, I wanted to be his height
I walked a little to dry in my throat
the storm…
all the words were detained
or perhaps they were written in white ink.
I reclaimed Arab history
I did not find any dream to borrow
so I shuddered anew:
how do you transform into lies?
that I may remain a detained throat
in the airports of the world, and yearn for the pure breeze of
my country
I go, I leave my love with addresses
nonexistent
and your beautiful eyes
anew
I wanted to draw the shape of its disfigured face
in you
slipping away like the tormented homeland between the wind
and the wings of the birds
in me

and I possess only my skin
and a dream in white ink
and two wide eyes, like the Carmel,
for all that was between us
and my stature erect
and appointments passing
according to Palestine's time...
perhaps you are more beautiful in your true form
maybe...
but I find myself a teardrop

on the scarf of my mother who hated its color
colorless
a dried-up tear on the scarf...
and for this I say to you:
I am ready for procreation
I know the truth
and I passionately love the breeze of my homeland
and the children in Beirut, and in Sakhneen
and I passionately love my pregnant storm
and the pomegranate!...

Published in Así canto yo, *1979.*
Translation by Lital Levy, Lena Salaymeh, and Adriana Valencia

Siham Daoud

The City that Gives Birth in Death

"Urushalim," the one that migrates in my body like the birds
and is distant like light and roots
The sea is far from you,
and the song of your daytime which we wrote on your
battlements
remained stingy
and the messiah's time will not arrive early
and the passing of lightning, and a shout
the lost gate through the cities of the East
and you asked me through death about a *qibla*
I placed it in the wall of the port
and the cross of the sun which remained in the harbor
of the dove...
Darkness persists, and all the surprises on my bed
bustle...
I sang an orphaned song in the cave
and the dust of the grave did not sing
so the messiah is born like you in death,
without a birth!...

Translation by Lital Levy, Lena Salaymeh, and Adriana Valencia

People of Figs

In the land of milk and honey
whenever they pick unripe dates
and children in their dawn
the pain dries
like curdled milk
rivers in my land will drip
the land of milk and honey

Translated by Karen Alkalay-Gut

As a Slaughtered Bird

Like a bird slain at the edge of time
Death has dealt us a terrible blow
We have concealed our ancient symbols
While the legend has reached us
Naked
From the Place

Rise, my son, take your horses
And stand tall
From different paths
At the edge of pain
Grind yourself
May a woman stir you
Lighting her baking fire
Sating her hunger

Leave behind your legends
Seep into your earth
The Place will lead you to the secret of its boundaries

Painted in red
You will leave her
Flutter your sheets in the wind
Beget your children
Under siege
Beget your offspring
On a window ledge
Your offspring who take on God
Rise and take with you the exuberant dynasty
Go and purify the words from the whispers
Enlighten your soul

As you move on

Add color
Mix the colors
In a body preparing to die
As it moves on
Abandoned by legends and religions
You are not alone
In death
At the edge of time
The old covenant has died like a slaughtered bird.
On the threshold
We died

Translated by Evan Fallenberg

People of Fire

Burn generations,
burn the olive leaves
raise incense,
burn their fingertips.
Smoke.
Burn their farewells
and go.
Burn their cookbooks
burn the kindling
infuse their wheat
and scatter it
on the rooftops.
They burn the candle's end
illuminate the shame of graves.
Dress in ashes and lie down like coals.

Translated by Karen Alkalay-Gut

Nidaa Khoury

People of Grapes

The unripe grapes
hang on the morning gate
and the leaving.
My soul goes out
to the unripe taste of my childhood
but the sun
grabs me quickly
and hides
my shadow
in her shade
…and my story ends.

Translated by Karen Alkalay-Gut

Nidaa Khoury

People of Olives

They come and are pressed
like those impressed with a Mission.
Thus thought the crushed:
In the crushing is most of the oil.
Our oil has been sold, like our blood
to the holy places
for we are poor
our land is holy
and our palace in the Mount of Olives.

Translated by Karen Alkalay-Gut

Nidaa Khoury

People of Pomegranates

Roll within themselves
seeds of love and liberty
from the dawn of time.
And now they break up
in the mother's hips
into wedges wedges
and she bursts
this is the land
narrow of womb
the place erupts.

Translated by Karen Alkalay-Gut

Nidaa Khoury

Death is a Wave

Death comes to me
Greets me with kisses
Never enough
Kisses me till death
Plants a thousand kisses in my body
In my waist and my chest
In my back it plants its seeds
My crazy lover
With him, I sip the street of kisses
Hiding from the looks of people
Behind the bombs of tear gas
Death harbors again flirting in waves
Death is the wheat that I grind
In my torment
And I promenade to the oven of the revolution
And the arches of the prison

Translated by Karen Alkalay-Gut

Aida Nasrallah

Abdulla

When Abdulla is filled with sorrow,
His shoulders embrace his eyebrows.
Eating himself, and leaning
On a chance,
He carries his provisions:
"Some olives and his mother's breath."

He presses them to his bosom,
And ties them to his waist,
Fearing about the slipping away
Of the remaining drops of warmth,
And wipes with his tattooed hands,
By the leaves of years,
A face like an old stone,
Spoiled by waters at the bottom of the ocean,

He smells twice,
Opens his mouth,
Yawning like an over-bored cat,
And moves his wood-feet,
Dragging his nose ahead of him
After a morsel!

Translated by Karen Alkalay-Gut

Hymns Without Rhyme

O, You, who are standing erect in front of me!
Filled into your frowning shirt,
Your body is a whale
That preferred imprisonment

Untie your nets!
Set yourself free!
Deflower the waves!
And raise the foam

Your frowning shirt will melt away!

Translated by Karen Alkalay-Gut

Aida Nasrallah

Just a Moment Ago

They were here
Still their beds healing their steps running in place
Their laughter still slips into the walls
Just a moment ago
I heard their music,
Their cigarettes still burning
The coats of men, of women,
Babies' dolls still whispering their songs
Still here
Before a final scream
Covered their dreams

Translated by Karen Alkalay-Gut

Aida Nasrallah

The Ceremony of Women

Every morning women perform their ancient ceremony
embracing their warm dreams
weaving their nostalgias for the water wells
and for the winds' song coming on the wings

*

every morning
women sew beds for their spoiled bodies
bleeding from the lust left from their eyelids
and like a spoiled lentil grain
grind their desires

*

in the morning
women beautified by yellow smiles
by counting the cups, the dresses, and the agony
of the loss of their erect breasts
women perform their old habits
plucking their hair, waiting for the coming moaning
spit out their old skin into coffee cups
rummaging for their eyes in the drifting smoke

*

but when the roar of the iron monster sweeps their heads
and when the blood spreads in the streets
and the dead gazes intertwine
the olive trees scream in the corners
then women change their ceremonies
hurl off their old meals made of nostalgia
their beautiful trifles

*

when the blood soaks the dreams
women change their ceremonies
and turn all into one scream.

Translated by Karen Alkalay-Gut

Mona Daher

Manifestations!

(1)
My pulses march
On the blueness of the clouds
So you can fall asleep.

(2)
On my sleepiness
You sleep
On the ruins of my love
You restore yours.

(3)
From mercy Eve was born
Do not go on shooting me
With the lava
Of your volcano.

(4)
As a man who keeps
Love hidden from me
You stutter
You wobble
And as though genies possess you
You mumble.

(5)
I am a woman fruit-laden as palm trees:
This love of yours
Will not suffice for me.

Translated by Karen Alkalay-Gut

Shyness

Nearby longing
I flirt with shyness in the eyes:
White-snow threads spreading
Across the expanse of nights.

On the edges of prairie
I take shyness off my details
I mount the madness of whispering
On the lips.

On the pasture of desire
I put on the shyness of
The rose
And the she-wolf masters
Savagery
In the heart of redolence.

Translated by Karen Alkalay-Gut

You Lost Me in the Scent of Frankincense

(1)
Slowly
 Slowly
You melted my heart: half into waves
 And the other sands.

(2)
On the melody of cooing
I harbor your breathing
Its cadence becomes mine
My words
Like candlelight
Flicker out
On you
And you
Flicker out
On me.

(3)
For Nietzsche: The woman is the comfort of a man after the battle.
For you: The woman is comfort after every raid.
For me: The woman, I, might, light and compassion.
You will be content with her…if your path and hers are just
If you ignite your narcissism and set it afire

(4)
On a neck, on my neck
A red rose
You defile it—in your dream:
Defiant breaths

Crush the rose
And leave it wet.

I say: Beware…beware…

Translated by Karen Alkalay-Gut

Windows

I trade my heart for a larger suitcase for those come to the fourth
 decade.
I count my black garments and prepare for the washing of the dead.
The clothesline gets longer and the umbilical cord gets shorter.
Only pity remains in the womb.

The firstborn son must wait awhile,
he can remain silent and play with the ornamental fish.
Afterwards he will break the air with serial cries.
Afterwards he will abandon the sea, the ornamental will die.

What remains will never come
as long as the snow turns to stones when it lands on the garden soil
as long as the wind shares the feathers
that will not be wings one day.

I long for you, for the way that does not know when to arrive.
The longings knock me flat on my face.
I bleed you, bleed names with no identity,
names that I forgot in my school notebook
feet I forgot in my childhood shoes
and eyes that I hung on colorful windows.

Translated by Vivian Eden and Salman Masalha

Nawal Naffaa'

Dust

He will bring me back home
he who brings my childhood back.
He will bring me back my childhood
he who wipes the dust of time
off the mirrors of my heart.

I have grown old, my soul has grown old.
Give me a cane, if you will, as a gift.
or allow me to lean
on your exile.

Translated by Vivian Eden and Salman Masalha

Stumble

I count corpses and airplanes
falling from the news broadcasts.
I count extracted bullets,
buried bullets
and bullets ready for firing.
I follow the eating rituals
devour the plate
finish the plate
after a hard day's work.

Since when have I been so hard?
Tomorrow I will clear a place for myself on your chest
to cry there.
Perhaps I will pull the corpses out of my chest
and hold proper rituals for their burial.

Translated by Vivian Eden and Salman Masalha

V

THE TEXTURE OF WORDS
French

Marlena Braester

as in a cobweb

as in a cobweb
I saunter in the alphabet this
Poem
Detaches itself comes toward me

this poem awoke me

it is taken the spider
between my starred fingers
it preys on me
the improbable one
I let it drop
on an imagined web
where the next poem takes shape

Translated by the author

Marlena Braester

in the sand notebook

to awake at the edge of the dawn
of this fragile break
at the edge of the desert
to write in the sand book
the impossible I
prepare myself in the slides of the
wind
deserted turned over
storm and his reverse
I always write
in the sand notebook
and the impossible I already
dispersed
letter after letter after
an abrupt wind carries the letters
toward a word
then
In the fold of this word
torn off to the storm
I awake at the edge of the desert
and without saying I
write in the notebook
of continuity

Translated by the author

Marlena Braester

the forgotten taste of crushed vowels

between two words the voice
loses its balance
glides on its reflection
in corners flashes of shadow
the speakers the writers buried
and in the mouth
the forgotten taste of crushed vowels

Translated by the author

Esther Orner

Minor Fissures

An old man is sitting behind an aging woman. Rather she is sitting beside him. Immediately after the burial, she had made her eclipse—I'm going back to my father, he is alone in his wheelchair. And the girl resembles her mother thirty years before. And they are there sitting side by side, looking at nothing. What are they thinking about? And what are the people saying who come to comfort them or simply to take leave from them? That no one believed the exhausted mother would be first to depart? No, something else. Such remarks are not made aloud.

*

Two sisters. They didn't always get along. Little squabbles. Little envies. Nothing very exceptional. With age, with separation, with distance, everything was once more in order. And when they met, even for several days, they avoided mentioning their childhood. And when at day's end they went to bed, one removed her hearing aid while the other put in her earplugs.

*

A home. On the heights. A view over the bay. They had arrived too late. The elderly lady was no longer there. They had made a small detour. The house was on their way. If only she had come to see her before, instead of writing to her that she had some-thing more important to deal with. Which must have angered the elderly lady. It was true nonetheless. But did she have to say it that way? The elderly lady could have waited. Once the matter was dealt with, she would have come to see her. Elderly ladies should never be kept waiting. No one should be. But can anyone really do otherwise?

*

Friendship ends when there is nothing more to say, said a very wise woman. Thus all these years would retreat into smoke, or

137

even into nothing? Not really, but one must know how to proceed elsewhere. Nothing is lost, the wise man said, because you will find it at the end of your days. The young man listened. He shrugged. The wise woman saw nothing. She was far away. Oceans separated them.

*

It is high summer. The dog days. In a tram, a few faded, elderly ladies with sparse blond hair. Only one elderly lady with abundant hair. And that would be a wig. She alone is seated. No one gives up a seat for these elderly ladies who seem to have come out of an old play, updated for today, where a couple of aged relatives in powder make old-fashioned movements and gestures while young people in modern dress ignore them.

*

A young man brought these lines from a little bench where they were carved:
> Some days you wake up in the morning
> And you find yourself immediately troubled
> Not that anything is wrong
> Only that you suspect silent forces
> Are working and trouble is ahead.

The young man wrote down the carved lines from the little bench numbered 16. He has just translated them into a third language. Hurried, he did not write down the original text. Treason of treasons. Mark these words quickly. It matters little which language. He too, on some days, can't prevent himself from asking why, why, as he continues onward.

*

Her door is barred. Behind her, someone is shouting things that she could have listed in advance—men all like nurses, even if they're not blonde, because they take care of men. She does not react. And it continues. Men like being taken care of. And women? She leaves the question unasked. And her door can remain barred. Here it may be a mother preventing her daughter from entering the room. Elsewhere a son who does not want his father there while he plays an instrument. Then the father listens quietly from behind the door.

*

A short remark can dog someone a whole lifetime, particularly if
it is all he remembers from years of weekly lessons. Thus when
presenting the genealogy of a writer under the medusan gaze,
even the snickers, of his students, suddenly he tells them: Laugh,
you can laugh, you are a generation without grandparents. The
students stop breathing. Their smiles freeze. And they listen all
the less. One woman, told this, said: As for me, I don't even have
a photo of them. I don't even know where I was conceived.

*

You need to change the arrangement of your room. Move the
furniture? Yes, that's it. She acquiesces with a light movement of
her head. And months later, nothing has changed. She decides to
tell a friend who always had good advice. Provided she doesn't
come give it in person. Yesterday she visited a friend. And when
she saw the great disarray of the main room, she showed
her admiration in shouts of gladness. And the friend admitted
that getting there had taken ten years. Then they set about look-
ing in their childhood, in their past unhappiness and uprootings,
for the cause of their inertia.

*

The mother, an enormous masculine woman, is sitting beside her
aging son who ever increasingly resembles a woman. He is
coquettish. He doesn't tell his age. He watches his figure like a
girl. But who is to say that these are feminine traits? What's for
certain is that with age, the traits become increasingly blurred.
From behind or from far off, a mistake is possible. Another
woman, much younger, blonde and enormous, is sitting beside a
thin little man. Her husband. A woman here, and he a man. She
is not masculine and he is not effeminate. They have been dead a
long time. Later it emerges that they had separate, distinct lives.

*

She has no answering machine. She is not really modern. Or
perhaps she is simply afraid of hearing things that should be said
face to face, or by phone if too far away. She could for example
receive this sort of message: X passed away, please phone. Or
this: I looked for you everywhere; where are you? While waiting,

she hears messages long as days on the neighbor's answering machine in a language she understands poorly.

*

Her scant conversation irritates her. She is there, seated. Suddenly stands. Makes a list for her errands. Women are always taken up with daily chores. During that time, men concentrate on leisure. What does she know about that, couldn't they be worrying about the bills they need to pay? After all, no one is ever at the point where they should be. And she, even when she is peeling vegetables, cutting them into little pieces, doing the dishes, hanging the laundry, what is she thinking if not of the one she will seat at her white table?

*

An aged lady, truly aged, bent in two, stops for a long moment in front of a boutique. Is she having a look at the miniskirts, or even at those trousers bunched at the ankle? What if she is simply having a rest before continuing on her way? Or what if, despite her advanced age, she has not lost her interest in new things?

*

She arose very early. She had scarcely swallowed her breakfast— she who considered it so important—before she set about writing a letter she was very proud of. Unlike her usual letters, this one was careful, well written; it flowed from the pen. She slipped it into an envelope, after rereading. The next day, after a good, calm and well-measured breakfast, she tore the letter into a thousand pieces. A pit for something so well written with neither cries nor tears.

Translated by Mark L. Levinson

VI

THRESHOLDS
English

Untitled

Because passion is the absence we speak
I am seeking another silence
to trace my transgressions,
step outside the frame of experience,
inform a book with divinity.
I know that dark descends
as I know the back of an honest man.
From the way he stands he is faithful,
free, face to face (with God?)
a mere back, yet I envy his
connection, so real the projection
of my loss. I stand in my own rejection,
remember what closeness would be like,
and know the faces I've lost.

From Unopened Letters

Linda Zisquit

Line of Defense

I don't let the news in at dawn.
I have rules for morning hours,
my ear strained to the warble
and whistle of returning birds.
If only I knew their names
or could decipher, on first
encounter, a plane circling
from a formation veering home,
wings flapping as if the sky's
performance deserved applause.
It's mad here, to maneuver
a day around explosions,
or to hold my pen as if
my words could keep danger
at bay, my son's safety
locked in this little plan.

An artist who paints the desert
mixes rosebuds and ashes
to harness gods that dwell
in hearths, to bring her daughter
health, protect her son.
And in the resin and sand
and pigment spilling around
I feel the force of matter
moving in perfect rhythm
with her love. I want
a poem like her painting,
a sensation of having
something in my control.

Remains

1
For a few seconds while I dozed
the water was mild, a green

long amphibian cruised just under
the surface, we slipped in

to bathe or cool off and stood watching
its graceful swift glide, watching

it turn toward us and propel itself
faster, watching it approach, too stunned

or confused to believe what we saw as if
onlookers ourselves in our own pool.

2
Like the painter who saves a trace
of color for the canvas ahead

I take my hint from the cycle past
so each borrowed line each betrayal

carries a shadow onto the pavement.
Bulbuls flock overhead onto a tall

tree, its mesh of branches against
the late afternoon, their loud yellow

hammering, their long tails, their booming
report. A Palestine sunbird

144

finds its way inside. I hear it
as soon as I enter, its high voice

a cathedral, our sunny house a prayer.
Let me out, it bangs

against the glass, let me out, it sings
into the sky-blue enclosure of a boy's room

and as I come close to open the screen
it stays frozen on the spread,

then flies up and out.

Lisa Katz

Jerusalem on Earth

Out of the city toward the desert the green fields turn yellow
passing from one season to another in an hour. Where there are
no people there is less blood. The almond trees bloom in January,
the poppies overtake the fields, also mustard. Thistles flower
purple as if to say, come and get me, and I'll sting you hard. This
is the real world, the world of nature.

In the other place the dead chant loudly: we were murdered. Or
they whisper behind their hands: we are murderers. And as they
are now without mass, they seem to have no gravity.

Lisa Katz

The Nun's Cemetery in Ein Kerem

In the hospice kitchen
the nuns peel leaves off artichokes, cut them in half
and eat the anatomical looking hearts
at their sisterly dinner.

No matter how hard they hoe all day in the flower garden,
drops of moisture spread onto their thighs
while they lie alone in the convent beds,
tossing, chanting the prayers of the childless.

Their wedding rings glint in the sun
as they scatter the seeds of the nasturtium,
push the freesia bulbs,
gnarled like human parts,
into the soft earth over the graves,
and pat the dirt and wait.

They tend their pungent garden and look over the high wall
toward the Church of St. John the Baptist,
who dunked them once under the surface of the water.
And they turn back to their work in the cemetery garden.

A bee buzzes, caught under a nun's long skirt.
Her head covering flutters in the breeze.
The flowers will pollinate each other.
There is nowhere that desire ends.

Shirley Kaufman

Untitled

All over Rehavia there are

tiny gardens
 green on the corners

in somebody's memory

 the name

incised on a concrete slab
 and a bench

with two immovable doves

blooms are staggered
 even in winter
when cyclamen jiggle the earth
and then the freesia

 stopping

to rest
 at the end of my block
two elderly women stare
straight ahead
 without speaking

hands folded
under their elbows

coming undone
a little
like braided straw
from too much handling
too many
losses in Europe
or here

wind bruises
their delicate foreheads
their skin
the color of water on sand
when summer is over
the shore undazzled

and all the children
have gone back to school.

Untitled

So we got out of Lebanon

out of the *botz* the mud

bitter
 dregs at the bottom
when the cup
 smashed

border
 as threshold

 what now
pressing against the barbed wire
whose flags
 blue star burning
and stones

 (it was fun said
the professor)

what scrupulous anxiety
 hovers

over the usual

 jay
its loud abrasive cry
in our jacaranda
 kiew kiew

why doesn't he sing why
does he sit there

 whole
in his unbleached body

steak-knife tail dazzle of
 blue
where the wing starts

repeating
 his screech his
portentous scold

 iyew iyew

Untitled

The trouble with anger
 Or with hate

is that it spills all over

 won't
be contained
 all over the threshold
and down the stairs

delivered in bottles
 it was the milk

exploded

 they sent me to get it

cold
 and slippery
over my Dr. Dentons

onto the hard porch

 tiny slivers

of glass
 and milk

like foam sloshing out of
my father's beer

all over

the table

 I wanted to lick it
like my cat

 maybe I'd bleed to death
and they'd be sorry

 but then

I smothered my cat
at least I took it to bed
and hid with it
 under the blanket

and that's what they told me

hated cats
 after

because I couldn't
 hate
 them

Rachel Tzvia Back

Palimpsest of Place

 Swell of hills across
Judea
 stretch
 to open clear
 between peaks where
sky

 slips lower
 into smooth cols—
 down slender neck, as sweat
 in crook of a collarbone—
sloped stunted shrubs
 half-burnt trees or absent
 trees
 coal dust on gnarled
 thornbushes, their tufted centers
 thick in place of
and the air
 parched,

 edges curling inward like bleached and
 brittle parchment

 here, in midday
 mid-range

at footslip on incline,
 where stones scattered
 are white markings
to nowhere

 in the bright glare of rays deflecting
 what I believe

 I see
 deeper into first sighting
 A dark and heavy shape
 move
 a buffalo

 wandered far from white
 cedar hickory red-berried hawthorne wild and ice-laced
 curled horns downturned
 head he carries low
 cannot raise but to shoulder level I think
 I see his body
 heave

 in this heat in this wavering
 air under the weight
 of this wide flame-white eastern
sky

 On Americans plains there were once
 sixty million, here
there were none

 though now I see him here
 as though returning
 remnant
 (dark thick-tongued ruminant
 massive beast of crowded herds)
 his solitary ruins
 to this narrowland
 still brown body
 in still and dry heat
 suspended

 the scene should be framed and hung on walls as

 is, as
 from anywhere
 in these hills—
 highpitch of air punctured—

 155

a single shot
in perfect flight through will
pierce fur
flesh and he too
will fall
another small
soon
indistinct
dark decomposing
heap
as ancient and pointless
as the rest

From The Buffalo Poems, *Shearsman Books,* 2007

(emptied house)

Outside the emptied house
there were soldiers on their knees
in the sand
sifting for body parts moving

forward in a line they
crawled inch by inch through
sand gravel glass and weeds
wild with metal splinters

in search of lost slivers
of flesh skin nails smallest
drops of not-yet dried blood
that would have been brothers

blown up on a patrol jeep and men
disappeared
into thin air this is no
smoke and mirrors magic trick

nothing left
resembling the human
but soldiers on their knees
in the sand

From The Buffalo Poems, *Shearsman Books,* 2007

Vivian Eden

Apology
With thanks to Helen Bacon

And to you just men who tried to acquit me:
before I go off to the place I must die
while those others are busy we still have time
to chat and exchange our fantasies
handling death like a painted egg
blown and adorned with figures from life
passed on and on to the man on the right
each finger smudging a fainter edge
as the membrane circles around
—counter in some puzzling game—
'til the colors wear out and we see within
the treasure even a king can't hoard:
that long, single night emptied of dreams.

Good friends, I thank you. Let it begin.

Vivian Eden

Memorial for a Man of Science
To my father

You have expectations of the earth. You say:
It should not be snowing at this elevation
Yet celestial caprices get in your way.

You can tell from cruising altitude which soil is clay
And in theory you would not object to cremation,
You have expectations of the earth. You say

In geological terms life is less than a day
And you know that we are tiny in time's calculation
Yet celestial caprices get in your way

You take us to the zoo when Mama goes to pray,
(Your heaven—swirling gases, your tobacco—Revelation).
You have expectations. Of the earth, you say

There are knowable rules that always hold sway.
Death is indifference to the Law of Gravitation
Yet celestial caprices get in your way

When you take me to see Anne Frank, the play,
You weep aloud, to my childish consternation.
Yes, celestial caprice does get in your way.
You have expectations of the earth. You say.

February 2002

159

Vivian Eden

Green Eyes After a Bad Nap

I woke from afternoon sleep
stupid and the bed was strewn
with sharp black thoughts
like olive pits upon a plate
not yet cleared away,
gnawed by fallen dreamteeth
of the kind that won't grown back.

I woke from afternoon sleep
jealous of that singing girl
whose three far breasts
pulse with vodka, milk and angst,
whose bright black eyes
like ripe olives on your plate
beg: Ride the scorpion's back.

Look, I don't want her blood or yours.
What I would like is coffee, please.

Karen Alkalay-Gut

Experience

How many wars have we seen?

I mean the ones that seared us
on the news, in the papers,
the wide screen, the water cooler
as well as those that hovered
over our heads, gnawed at the door,
made only our blankets seem
a safe cover.

　　　　When I think of
what our eyes have seen,
our ears have heard
it is no wonder
we can't even dream
of peace as more than

an easy word.

Karen Alkalay-Gut

After

I would probably have been okay
I mean I didn't even know
for sure it was actually rape
until I got home and saw the blood
and nothing really hurt
except where my head
got slammed against the steering wheel.

But the old stories were true:
I was damaged goods
From that very moment

There was a guy named Ritchie
who was nice the first day
in science lab, and sat with me on the stairs
while I blubbered away—
but he lost patience or maybe
got warned that frat boys stick together
—and suddenly switched lab partners
and never talked to me again
except to warn me that women
who cried rape could easily be turned
into whores in court.

I missed him, but I guess I understood.

Intifada Child

He wets his bed at night and in the morning
runs to the junction to throw stones. What
did he eat for breakfast? Who washes his clothes
when he comes home at dusk full of dust and the sight
of his friends (from the same bench at school)
fallen in blood? Behind him his uncles
are urging him on and shooting over his head
at soldiers still boys themselves. In the kitchen Mother
wrings her hands and takes comfort in the fact
that her child is her savior, alive or dead.

I too dream of you every night, child,
small and scrappy and hard to control,
determined to change the direction of generations,
full of disdain for the days just gone by,
sure you can make it by the force of your anger.
I dream of you not as your foe, but as one
who has heard screams like yours in the night
and do not want to reassure you with dreams of paradise
for martyrs, as one who has grown up with my own
enemies and bogeyman, have known their children
holding up their hands at rifle point on the streets,
walk every day with brothers and sisters
who died before I was born.
And in my dreams I hold you and feed you and read you
a rairy tale, a bedtime story, still believing I can keep your fears
from growing up true, teaching you gently
from your folklore and mine, tucking you in
and promising to wake you
with a new morning.

163

VII

BLUE SKY
Russian/Polish/German/Finnish

Gali-Dana Singer

Second Letter

Today I wanted to talk with you
about our imperfect walks
imperfect from the point of view of good taste
if you remember
we gave them names—
for example, the Friendship Rambles or the Wandering of the Reckless
and you condemned me when I cursed: "Damn it."
Rose blotters from a math notebook fluttered in the air
spreading the scent of cheap perfume—Mademoiselle
de Scudery —which smells like lime or flea soap.
and here the bougainvillea have such varied shades
petals blue as veins, those in the photo
are called plumbago
and they are waiting for an unforgivable rhyme
I'd rather forget about the rhyme and meter
and the rest of the hellish matters
and not talk about fire or brimstone
end quote
and the beginning of the new one—
passiflora teaches each wall and fence the grammar of refinement/
preciousness,
turning them into flower stands, into a substitute for stands in the
absence of standards
not retirees in knit gloves tending the flock of garden pots,
simply pay the Arab his money on time
how easy!
it isn't exactly filigree
and afterwards without a witness, voyeur or neighbor
they enjoy the afternoon nap of the fawn
in the bitter orange grove
in the space of a square meter and no more

and whoever's in a hurry adds luster—
each one to his own orange tree—
varnishes, polishes, and it's greenish anyway
and returns exhausted to rest.
As long as a frustrated Young Pioneer carries a knapsack on her back
for good posture
as long as a toddler from October's children scratches the asphalt
with a sled
and the blue plumbago look out from eyes of folly
as long as the passiflora vines are pressed to the wall, hair turning silver
they hide the graying curls between the stones of Judea
arrange the veil lower on the forehead
grabbing the hat with paper passiflora
and already in the month of Iyar
everyone lifts a lace parasol
like a drawing of a lighthouse among waves of folklore
from the *lycée*
or from the *Annenschule*:
See how SEMICOLON is strutting with pride!
Into two or more parts he'll a sentence divide.

After all not many opportunities
to remember patchouli
and a cluster of snowballs in a pitcher
and the game "Forfeits"
and collars with embroidery *anglaise*—
exactly like the ones I used to have
made out of grandmother's drawers
to be exact the drawers that were made into curtains
and to be reminded of eau de cologne again
for the unrefreshing rhymes
that never change
that have never changed since the *lycée*
or the *Annenschule*
where your parents studied, Nekoda's father, my brother, Tamara Silman,
it seems to me, Admoni, Baron Tisenhausen, Menaker, Katzenellenbogen
and Donde
¿a dónde? where to?

167

¿de dónde? where from?
¿por dónde? how?

Donde Regina
the nuisance and "don't touch me"
chronic sore throat
Regina Samoilovna Donde showing off in her moth-eaten fur
takes herself for a stroll and catches a cold again
and the *Annenschule* is buzzing:
In the dark alleyways—Isn't it droll!
Katzenellenbogen kisses in return for a roll.
¿Dónde las dan, las toman?
a dónde? where to?
as long as the passiflora grant preciousness
to every handrail that continues with their help
I swear to you I can forget even Leningrad—
remembering only the houses and thinking only about my
brother
and because "grad" is no longer a city in Russian but rather "hail"
and as long as the passiflora steal upon the whitewash.
I don't dare find them a place, not in the poems, and not between the lines
as long as the passiflora creep up the wall
I'm familiar with their whispering
not even the sounds but signs of notes
hesitant attempts
like eyeliner smeared on a cheek
perhaps I'm too specific for nothing
but listen
you know—what is called "jasmine" here
isn't jasmine but something completely different.
Not long ago I searched the book of plants?
and all I got for it was a headache
I didn't even find a trace of what we call jasmine
or was it just the fragrance. I doubt it.

Translated by the author

Else Lasker-Schüler

My Mother

Was she the great angel,
Who walked alongside me?

Or does my mother lie buried
Under the smoke-filled heaven—
It never bloomed blue over her death.

Would that my eyes had been radiant,
Bringing her light.

Were my smile not submerged in my countenance,
I should suspend it over her grave.

But I know a star,
Where it's always day;
I shall carry it over her earth.

Now I shall be all alone
Like that great angel,
Who walked alongside me.

Translated by Johannes Beilharz

To My Child

You will die again and again to me
In each departing year, my child,

When the leaves scatter
And the boughs grow thin.

With red roses
You tasted death bitterly,

You were not spared
One single withering beat.

Thus I cry so, eternally...
In the night of my heart.

The lullabies still sigh from me,
That sobbed you into the sleep of death,

And my eyes no longer turn
Toward the world;

The green foliage blinds them.
—Yet the eternal lives in me.

My love for you is the sole image
Of God a human is allowed.

Through my tears in the wind and hail,
I also saw the angels.

They hovered...

In heavenlike air.

When the moon is in flower,
My child, it resembles your life,

And I do not want to see
The butterfly—light-giving and care-less—float.

I never divined your death
—Never felt it surrounding you, my child—

And I love the walls of the room
I paint with your boyish likeness.

The sparkling stars that in this month
Fall, numerous, into the world
Drop heavily upon my heart.

Translated by Johannes Beilharz

Jerusalem

God formed out of his spine: Palestine
Out of one single bone: Jerusalem.

I wander as through mausoleums—
Our holy city turned to stone.
Stones lie along the bed of her dead waters
Instead of the water-silk at play: flowing and ebbing.

Transfixed by earth's cold stare,
The wanderer founders in the starry chill of her nights.
There is a fear I cannot overcome.

Were you to come...wrapped in a snow-bright Alpen-coat
And take the twilight of my day—
My arm would encircle you, framing a holy image.

As once, when I suffered in the dark of my heart—
There were both your eyes: blue clouds.
They took me from my melancholy.

Were you to come—
To this ancestral land—
You would reproach me like a little child:
Jerusalem, arise and live again!

We are greeted by
Living banners of One God,
Greening hands, sowing the breath of life.

Translated by Johannes Beilharz

Renata Jabloska

Cain and Abel

Cain and Abel are the prototype
whole masses sprung from them
since that age

every Abel has his Cain
every Cain has his Abel
and continually kills him
and will go on killing him

Translated by Alysa Valles

Renata Jabloska

hands

a heart driven by despair
to the limit of endurance
quickens its pace

weakened knees barely
hold up a body heavy
with terror

trembling thoughts hide
one after another

and only the wise hands
calmly and confidently
offer you a spoon of fear
and support your head
to make it go down easier

they straighten pillow and quilt
then gently stroke
your forehead and hair
long enough to silence in you
the murmurs of pain

Translated by Alysa Valles

Renata Jabloska

waves

drunken waves are lapping the shore
on the sand moist with this tenderness
are the prints made by my bare feet
tongues of water wipe away their traces

I look over my shoulder
I walked a long way along the beach's wavy edges
but the one pair of footprints not yet
washed away give the impression as if
I had suddenly sprung up in this place

perhaps I did
perhaps I didn't exist before
because now I am different
no longer the one who an hour ago
walked out to the sea

Translated by Alysa Valles

Julia Wiener

A cat on a highway

A cat is running along a roadside
buses and other vehicles are rushing by
The cat is intending
to cross to the other side
it seems to her
that over there it's better

The cat looks to the right, looks to the left
Both right and left
the cars are still far away and harmless
but the cat hesitates
the highway is wide and dangerous
Yet at the last moment
as the cars from both directions
are nearly meeting in the middle
the cat makes up her mind
over there, on the other side
it's much better and nicer

The cat crosses the road
and a car runs her over
not out of cruelty, not on purpose
but such are the laws of a highway

The life-system of a cat is uncommonly durable
The cat is still alive although she will not live
Having lost her former cat-like aspect
she crawls among the shrubs
where she tries to recover
the shattered process of life

However, the injuries are too extensive
there are too many fragments and tears
too many crushed tissues both soft and hard
too large is the amount
of the fluid substances spilt

Having reviewed quickly the damage
and correctly estimated the situation as hopeless
the cat however for quite a while
goes sealing the tears
knitting the fractures
brazing the vessels
closing the wounds
in an effort to restore the corrupted shapes

But she cannot manage in time
The process of disintegration
is ahead of the process of restoration
One after the other, the half-alive systems
obeying the command of the half-dead center
disconnect and fall
The cat gives up and dies
although on the other side of the highway

Translated by the author

The Night Hours

Ten minutes to ten
It might have been worse
it might have been ten to eleven
or even ten to twelve
Quick, quick, do the undone
quick, quick, finish the unfinished—
it cannot be left for tomorrow

Eleven o'clock, even a little later
the day is practically over
Okay, so today I didn't quite manage
today it didn't come out
No matter, there's always another day
perhaps I'll manage tomorrow
tomorrow I'll do everything differently and better

The clock struck midnight
struck a hole into the next day
an insuperable abyss not to be jumped over
Yet I, by a stroke of luck,
found myself on the other side ·
So then
I may go to bed again

Just after two
For yesterday—too late, for today—too early
Not knowing which side to join
the time froze
and isn't moving
(the clock says that it is
just manage to live through fifty more minutes

and it would be three o'clock
practically morning)

Half past three
Just the right time to half-wake up
and to awake the one who's lying next to you
Time aplenty to sleep afterwards
holding him tight in your arms
But if you're sleepless alone—
Quickly swallow a pill
Do not wait for four o'clock—a dangerous hour

Five in the morning. I won't die at night
It's light outside but it doesn't bother me
Some folks are already going to work—
so much the worse for them
so much the better for me
To turn off the hysterical alarm clock
and to dive into the safe waves
Welcome, you sweet medicated sleep!

Eight o'clock. Rise and shine
The yesterday ghosts have remained in yesterday
Everything anew, everything's possible everything's feasible
plenty of time for everything
An endless, cloudless day is lying ahead
which only sometime
somewhere
perhaps
will end in a night

Translated by the author

My Family on my Father's Side
(fragment)

1.
in the jewish townlet of khshanov
there isn't a single jew
once upon a time long long ago
the good god waved his magic wand
and the jews there ceased to be

at the polish townlet of khshanov
there is a jewish ghetto
an exemplary jewish ghetto
surrounded by a tall stone wall
locked forever with an iron lock
good jews are kept in there
jews who behave themselves in an exemplary fashion
they know their proper place
they do not quarrel do not yell do not try to break out
they never steal trade from their neighbors
and bother neither the decent people
nor their cantankerous god
(*vav-yod-nun-resh*
the rounded stones are whispering to each other
vav-yod-nun-resh)
happy jews are kept in there
my great-grandfathers and their fathers
undisturbed but for the worms and the moles
serenely are they awaiting the coming of the messiah
and to his call they'll rise with all their gold teeth
with their skin and hair untouched by human hand

an exemplary Jewish ghetto
a cultural asset of the polish nation

2.

in his youth my grandfather zelig-felix loved all kinds of trinkets
yet he wore them only to a fair or to the stock exchange in warsaw
and on the way back as the train was nearing khshanov
he would take off his cufflinks his gold chain and his cornelian signet
and leave them all for safekeeping with a friendly conductor
however one day overexcited by a successful transaction
(later on his successes were so many that they ceased to excite him)
he forgot all caution and came off the train in his finery

at the station he was met by reb leiba my great-grandfather
reb leiba saw his son all dolled up in the goyish fashion
and gave him a slap in the face

my grandfather zelig-felix put his hand under his chin
to stop the blood from running onto his starched shirtfront
and reb leiba said
it wouldn't do to disinherit my eldest male offspring
yet apparently he's getting too big for my house
why don't you go son and start a business in vienna
i'm sure you'll find vienna to your liking

the year was nineteen hundred and eleven
life was quite good to the jews in vienna
as is their wont
they expected this state of things to go on forever

3.

my aunt franzi said we are leaving vienna
it was the summer of nineteen thirty-five and the weather was perfect

her husband uncle fritz a young and fashionable interior designer
went to his study
cleared his sofa of sketches for the von eckerstahls' new villa
took off his cream-colored silk blouse
his white tussore trousers
and his pleated summer sandals
he put on his persian dressing gown

181

lay down on the sofa
and covered himself head to foot with a plaid bought in scotland

we are leaving vienna said aunt franzi to her favorite sister erna
god what a scaredy-cat you are cried my aunt erna

we are leaving vienna said aunt franzi to her brother shachne
girl you are ruining your husband's career said my uncle shachne

we are leaving vienna said aunt franzi to her father
my willful kitten my grandfather zelig-felix said fondly
and lightly tapped her smooth white forehead with the knob of his cane
while uncle fritz was still lying on the sofa
with his head under the scottish blanket

my frail blue-eyed aunt franzi
the spoiled baby of the family
will of iron under the peach-cream skin
tough neck under the golden curls
she liquidated all property
her own and uncle fritz's
and transferred the capital to london
she packed up her beautiful fin-de-siècle furniture
and dispatched it by sea to london
she arranged in boxes the collection of roman glassware
the rare early toulouse-lautrec posters
and the post-impressionist paintings
acquired by fritz when they were still affordable
she insured the lot she paid all the taxes
she greased all the palms that needed greasing
and sent everything to london

then she walked up to the sofa
pulled the plaid off the head of her husband
and said fritz we are leaving vienna forever
go say goodbye to friends and family members
fritz and franzi passed away in london forty odd years later

he from pneumonia
she from cancer of the stomach
never again did they see their relatives or friends

4.

after the emissary from palestine had departed
aunt zelda aunt gita and uncle shachne
stayed for a long while in their living room
discussing the peculiar stranger

have you noticed the necktie he was wearing
well you wouldn't expect them to wear ties over there would you
and his gaiters the black gaiters with the brown suit
oh stop it aunt gita said the laughing hurts me
and what a name he invented for himself dov even-sapir
just a common *berele shapira* i'm sure
yes but he's got a letter of introduction from doctor marmurstein
good idea let the doctor himself go with the palestinian yokel
he's just the right kind of a misanthrope and a failure

5.
no
 said rudy von lissitzky to my uncle shachne
never shall i find myself another friend like you
never shall i have such a partner to do sparring at the sports club
to discuss *kokoshka* and *kiete colwitz*
to argue about richard strauss and kierkegaard
to wander at night through the streets of springtime vienna

all this cannot last long said my uncle shachne
they just want to exploit us as cheap labor
i'll be back in no time and everything'll come back again
just wait and see the muscles i'll have developed

do not try to comfort me said rudy von lissitzky
i know this is a loss that cannot be avoided
we always sacrifice for the fatherland our best assets

6.

when my aunt gita drank her morning coffee
her maid would remove carefully the skin from the warm cream
the sight of skin caused nervous spasms to my aunt gita

when a seamstress sewed panties for my aunt gita
she would put soft silk ribbon over the seams
uncovered seams irritated aunt gita's tender body

when my aunt gita went to see a moving picture
her escort would buy all the seats around her
closeness of other people discomforted my aunt gita

when the transport arrived in treblinka
my aunt gita was lying in frozen urine on the floor of the car
but she was still alive

Translated by Julia Wiener

Galit Hasan-Rokem

In Finnish there is a name for a snow heap,
for a snow plain, for its top layer hardening
to ice, thin or thick, for the crack
in which you may suddenly be engulfed walking on the freezing
 lake

Translated by Shirley Kaufman

Galit Hasan-Rokem

Grunewald, Spring

For Amos Hetz

Standing on the blue bridge,
nothing to hold us up
except
the decision to stand here now,

we are waiting for the nightingales to sing.
Perhaps because the night is clear
perhaps because of the moon
they are not making a sound.

Only the acquired knowledge
of their astonishing coloratura
arouses
our memory. Like

the shadows of the high trees
on the edges of the lake,
in Böcklin's Island of the Dead,
perhaps the colors.

The bridge stands between
the banks. Concrete and iron
hold us up for the moment.

Translated by Shirley Kaufman

BIOGRAPHIES of POETS

Karen Alkalay-Gut was born during the last night of the buzz bombs in the Blitz of London to parents who had narrowly escaped death in Danzig (Gdansk). Her sense of the precariousness of life and the necessity for immersion in it derives from this. When she was three her family was deported, and they immigrated to the United States. She received her Ph.D. from the University of Rochester, and moved to Israel in 1972. Since then she has lived in Tel Aviv and taught at Tel Aviv University. She has published more than 20 volumes of poetry and a biography of the Rochester poet, Adelaide Crapsey, and she currently chairs the Israel Association of Writers in English.

Pnina Amit was born in Israel, the daughter of Holocaust survivors who came to the country in 1949. She graduated from Tel Aviv University in the fields of psychology and philosophy. Her poetry and translations have appeared in the major Israeli newspapers, and she has also collaborated with Israel's noted painter Menache Kadishman. Among her works are *Outside Connection*, a novel (1996), *Voices and Genesis*, a collection of poems (2005), and *Fireflies of Music* (2000).

Sylvia Aron came to Israel from Chile at the age of 13. She writes in Spanish and evokes the nostalgia for her home in South America. She is the author of three collections of poems and lives in Tel Aviv.

Rivke Basman Ben-Chaim is the author of more than eight books of poetry since 1959. She was born in Willkomir, Lithuania, in 1925. She survived the Vilna ghetto and the concentration camps and, after the war, became active in the Flight and Rescue mission that brought Jewish survivors to Eretz Yisroel. In 1947, she made *aliyah* and fought with the Haganah during the 1948 War of Independence. Basman Ben-Chaim was one of the founders of the Israeli Yiddish literary group, Yung-Yisroel, in 1951. She lives near Tel Aviv and, through Beit Leivick, the Yiddish writers' house, co-edits the journal *Toplpunkt*. Her most recent book is *Af a strune fun regn* (*On a String of the Rain*).

187

Maya Bejarano was born in Israel and lived in Jerusalem from 1973 to 1978, where she wrote prose and short stories and worked in the bibliographical section of the Hebrew University Library. She now lives in Tel Aviv, where she lectures and holds poetry workshops. She is the author of ten books of poetry, among them *Selected Poems 1972–1986*, *Voice*, and *Beauty Is Rage*. She has also collaborated with many artists and painters.

Irene Bleier Lewenhoff was born in Uruguay in 1950 and moved to Israel in 1967, where she lived for three years in Kibbut Metzer. She now resides in Tel Aviv, where she works as a nurse. She has published two books of poetry, and many of her poems have been translated into Hebrew. She is also member of Doctors for Human Rights.

Marlena Braester was born in Romania and immigrated to Israel in 1980. She received her doctorate in linguistics from the Université de Paris VIII in 1991. Her publications include many books of poetry and translations. Her poems have appeared in magazines such as *Ariel*, *Le Journal des Poètes*, and *Shevo*, among others. They have also been translated into English, Arabic, Spanish, Italian, Croatian, and Hebrew.

Tamara Broder-Melnick was born in Prague in 1950. Her parents, Polish diplomats, speak Polish at home and Czech elsewhere. In 1957, the Broder family immigrated to Chile. During the 13 years she lived in Chile, she learned Spanish. At age 20 she emigrated to Israel, where she continues to write poetry in Spanish, the language of dreams, liberating metaphors, and associations.

Mona Daher, an educator who has written about and studied the condition of the Palestinian woman, lives in Nazareth. She also writes for several Arabic and French newspapers. She has published five collections of poetry in Nazareth as well as in Cairo and Lebanon. Among her most distinguished books are *Lilac* (2001) and *The Taste of the Apple* (2003). Daher is active in international literary associations and is often invited to poetry festivals around the world.

Siham Daoud was born in Ramle and currently lives in Haifa. Her poetry, which has won considerable acclaim in the Arab world, is personal but with nationalist political undertones, and includes poems on nature, loneliness, and anguish which, according to the 1990 Jerusalem International Poetry Festival catalogue, "turn into cries of protest." She is the editor of *Masharif*, one of the leading literary journals in the Arab

world, and she also is the director of the Haifa-based publishing house Arabesque.

Vivian Eden was born in New York in 1946 and raised in Washington, D.C. She attended Barnard College for a year, then completed her B.A. in English and sociology and her M.A. in English language and literature at the Hebrew University of Jerusalem. She returned to New York to do graduate work in theater at Columbia University, and completed her doctorate in comparative literature with a specialization in translation at the University of Iowa, where she worked for some years in the International Writing Program. She currently works for *Haaretz English Edition*, a daily newspaper that appears together with the *International Herald Tribune* and for which she writes an occasional column of Hebrew poetry in translation. Her articles, book reviews, and literary translations have appeared in newspapers and journals in the United States, Britain, Israel, and elsewhere. A number of her poems have been published in Hebrew translation.

Haya Esther is both a poet and painter in whose work the expression of erotic love is a constant. She is the author of several works of poetry, and her painting has been exhibited in Israel. She is the recipient of the Prime Minister's Prize for outstanding cultural contributions.

Rukhl Fishman was born in the United States in 1935. At the age of 19 she immigrated to Israel, where she settled on a kibbutz and wrote poetry in Yiddish.

Michal Govrin is an Israeli writer, poet, and theater director born in Tel Aviv. Her father was one of Israel's first pioneers, and her mother was a Holocaust survivor. Govrin has published eight books of poetry and fiction. Her novel *The Name* (1995), which was the recipient of the Kugel Literary Prize in Israel, and its English translation (1998) were nominated for the Koret Jewish Book Award, and her novel *Snapshots* (2002) received the 2003 Akum Prize for the Best Literary Achievement of the Year. Among Govrin's acclaimed and award-winning theater works are *Mercier and Camier*, based on Samuel Beckett's novel, as well as *The Workshop* by Grumberg, *That Night's Seder*, and *Gog and Magog*, based on Martin Buber's Hassidic novel. Govrin received her Ph.D. at the University of Paris for the study of Jewish Ritual and Theater. She is married with two daughters and resides in Jerusalem.

Schulamith Halevy is a native of Lucerne, Switzerland. She is a scholar

of comparative religion specializing in *aggadah*. As an undergraduate she attended the Jerusalem College for Women, and she received an M.A. in history from the University of Illinois in 1981 and studied at the Hebrew University in Jerusalem. Her graduate studies focused on the intellectual and cultural history of Islam, Judaism, and early Christianity. Halevy is fluent in Hebrew and English and reads in German, Aramaic, Greek, Arabic, and Coptic. She has published an award-winning book of poetry, *Interior Castle*, which tells the story of the descendants of the Jews expelled from Spain and Portugal.

Hedva Harechavi is a graduate of the Bezalel School of Art and has held one-woman art exhibitions in Israel and abroad. She has published three volumes of poetry and won several literary prizes. Her poems have been translated and anthologized in English and Russian.

Galit Hasan-Rokem, a married mother of three, was born in Helsinki, Finland, and immigrated to Israel in 1957. She is a Grunwald Professor of Folklore at the Hebrew University, where she teaches in the department of Hebrew Literature and the Jewish and Comparative Folklore program. She was head of the Mandel Institute of Jewish Studies at the Hebrew University of Jerusalem from 2001 to 2004, and president of the International Society for Folk Narrative Research from 1998 to 2005.

Sharon Hass was born in Israel. She is a poet, essayist, and editor who studied and taught classics at Tel Aviv University and now lectures on literature and poetry at the Kerem Institute for Teachers in Jerusalem. In 2006 she served as a visiting poet at the Hebrew University in Jerusalem. Her contributions to Israeli life and letters were honored by the Prime Minister's Award for Writers. Most of her poetry involves mythical images, and she deals extensively with experiences on the borders between reality, legend, and dream.

Michal Held was born in Israel and lives in Jerusalem. Her first book of poetry, *Time of the Pomegranate* (1996), won a prize from the Association of Hebrew Writers. Her second collection of poems received a grant from the Amos Foundation established by Israeli President Shazar. This collection is unique in the fact that in it, Hebrew and Judeo-Spanish (Ladino) are fused to form a multilayered poetic world. Dr. Held lectures on Judeo-Spanish literature and culture at the Hebrew University of Jerusalem's center for the study of Jewish languages and literatures. Her Ph.D. dissertation, devoted to the analysis of the per-

sonal narratives of Judeo-Spanish–speaking women storytellers, will be published in the near future by Jerusalem's Ben-Zvi Institute.

Yehudit Ben-Zvi Heller, a poet and translator, was born and raised in Israel. Her poetry and translations have appeared in a number of Israeli and American literary reviews. Her books of poetry, *Ha'isha Beme'il Sagol (The Woman in the Purple Coat)*, 1996, and *Kan Gam Bakayitz Hageshem Yored (Here, Even in the Summer it Rains)*, 2003, were published by Eked Publishing in Tel-Aviv. She is currently a doctoral candidate in comparative literature at the University of Massachusetts at Amherst. She has taught numerous literature courses there, as well as Hebrew at Smith College.

Ilana Hornung-Shahaf, born in Haifa to Holocaust survivors, is the founder and director of the Annual Poetry Festival of the Desert (Yemei Shira Bamidbar) held in Sde Boker. She has a BA in English language and literature and Hebrew literature, as well as a BEd from Haifa University and an master's degree in Hebrew literature from Ben Gurion University. For the past two decades she has lived in the Negev, teaching literature and the art and techniques of translation to high-schoolers. Among her publications are her poetry books *A Broken Cycle* (1989) and *Neither Wind Nor Thunder* (1991), and a children's book on David Ben Gurion's childhood, *The Magic Box*.

Renata Jablonska was born in Poland four years before the outbreak of WWII. In 1954, she began her studies at Lodz University in the faculty of philology. In 1957 she moved to Israel, where she worked as a teacher and journalist and taught Polish at Tel Aviv University. She writes in Polish, both poetry and prose, and translates Hebrew literature into Polish. Four of her books were published in Poland: *Dream for Four Hands* (1995), *The Song of Chameleon* (2000), *Chamsin* (2002), and *The Vanished Faces* (2004). Her book *King Albert Square* was published in Tel Aviv. Her short stories have been published in Poland, Israel, the United States, and Germany.

Lisa Katz was born in New York and moved to Israel in 1983, receiving a Ph.D. in English for her study of the poetry of Sylvia Plath from the Hebrew University, where she teaches literary translation. She serves as co-editor of the Israeli pages of the Poetry International Web Project for world poetry in translation; her translations of Israeli literature have appeared in *The New Yorker*, *The American Poetry Review*, *Prairie Schooner*, and many other journals. In 2006, a volume of her poetry in

Hebrew translation appeared in Israel; in the United States, her translation of Agi Mishol's *Look There* was published by Graywolf Press. An essay on Plath is forthcoming in *European Contributions to American Studies*.

Shirley Kaufman is an American poet and translator who has lived in Israel for 30 years. Her earliest collection of poems, *The Floor Keeps Turning*, won the first-book award of the International Poetry Forum in Pittsburgh in 1969. Since then, seven more volumes of her poems have been published, including *Roots in the Air: New and Selected Poems*. She has also published books of her of translations of contemporary Hebrew poetry, including *But What: Selected Poems*, by Judith Herzberg. She has received fellowships from the National Endowment for the Arts and the Rockefeller Foundation, as well as the Shelley Memorial Award from the Poetry Society of America.

Nidaa Khoury was born in the Upper Galilee village of Fassouta in 1959. She has published seven books of poetry in Arabic that have been translated into several languages. *The Barefoot River* was published in both Arabic and Hebrew, and *The Bitter Crown*, censored by the Jordanians in 1997, was republished as *Rings of Salt* in 1998. Khouri's poetry has been the subject of studies at the University of Haifa and the Hebrew University and has been widely reviewed in the Arab press. She has been an active participant in international poetry conferences, including the Conference of Arab Poets held in Amsterdam and the Conference of Human Rights and Solidarity with the Third World in Paris. She teaches creative writing in the town of Tarshiha, and works for the Association of Forty, an organization that promotes human rights and the full acceptance of the unrecognized Arab villages in Israel.

Else Laske-Schüler is considered one of the most important German poets of the twentieth century. At the same time, critics consider her a poet of Israel and especially Jerusalem, where she eventually made her home. Her presence continues to illuminate the writings of many poets included here in this volume. Among her most important works pertinent to our collection is *Hebrew Ballads and Other Poems*.

Elvira Levy is a distinguished Argentine journalist and poet who was born and raised in Buenos Aires, then moved to Spain and finally to Jerusalem, where she lives and contributes to the growing community of Spanish-speaking poets living there. Among her most important

books are *Hablando con Borges* and *Bifurcación de la memoria*.

Margalit Matitiahu was born in Tel Aviv, where her parents, Spanish Jews from León, Spain, settled after leaving Salonika, Greece. At a young age, Margalit learned Ladino from them, and also studied Hebrew literature and philosophy at the University of Bar-Ilan. She began writing in Hebrew and Ladino at age 15. She has published numerous books: *Despertar el silencio*, 2004; *Alegrica*, 2002; *Matriz de luz y vela de la luz*, 2000; and *Camino de tormento*, 2001. Her books in Hebrew include *Por el vidrio de la ventana*, 1997; *El silencio veraniego*, 1979; *Cartas blancas*, 1983; and *Escaleras de medianoche*, 1995.

Sabina Messeg was born in Sofia, Bulgaria, in 1942 and came to Israel in 1948. She grew up in Jaffa, and after her military service settled in a *moshav* (a cooperative agricultural settlement), where she lived with her family for 30 years before moving to a small village in the Galilee highlands. Messeg studied Hebrew and English literature at the Hebrew University and Tel Aviv University. She writes for adults as well as for children (under the pseudonym Adula), and translates English and French poetry. She is the recipient of the 1982 Newman Award and the 1994 Ze'ev Prize for Children's Literature. She has published five books of poetry.

Rivka Miriam, daughter of the Yiddish writer Leib Rochman, was born in 1952 in Jerusalem, where she continues to live and work. Her first poetry collection was published in 1966, when she was 14. She has published ten books of poetry, two collections of short stories, and two children's books. Her works include *Poems of Stone Mothers* (1988), *Place, Tiger* (1994), *Nearby Was the East* (1996), and *Resting Jew* (2000). She has received numerous literary awards, and has twice been awarded the Prime Minister's Award. She is also a painter who has exhibited in solo and group shows and is head of Elul, a Jewish studies center in Jerusalem.

Agi Mishol was born in Hungary in 1947 and brought to Israel as a very young child. She is the author of 12 books of poetry and the winner of every major Israeli poetry prize, including the first Yehuda Amichai Prize awarded in 2002. Her latest books, *New and Selected Poems* and *Moment*, recently moved into their fifth and second printings, respectively; a group of her poems has been dramatized in a play, *The Owl Ladies*, and a jazz CD based on *Moment* has been produced. A teacher of poetry workshops at Tel Aviv University and lecturer in literature at Alma

College, Mishol holds BA and MA degrees in Hebrew literature from the Hebrew University. She lives on a farm in Gedera, Israel.

Kadya Molodowsky (1894–1975) was a major figure in the Yiddish literary scene in Warsaw from the 1920s through 1935, in Tel Aviv from 1949 to 1952, and in New York, where she lived from 1935 until her death. A teacher in the Yiddish schools in Warsaw as a young woman, she was best known for her children's poems. After she came to the United States, she wrote for the Yiddish press and founded a literary journal, *Sviva* (Surroundings), which she edited for three decades. She published six major books of poems between 1927 and 1965, as well as plays and essays, two novels, and a collection of short stories. In 1971, Molodowsky was awarded the Itsik Manger Prize. During the three years she lived in Israel, Molodowsky edited the Pioneer Women's Organization's journal *Heym* (Home), began writing the novel *Baym toyer: roman fun dem lebn in yisroel (At the Gate: A Novel of Life in Israel)*, and wrote a chapbook of poems, *In yerushalyim kumen malokhim (In Jerusalem, Angels Come)*, from which the poems included here are translated. A bilingual edition of her poems, *Paper Bridges: Selected Poems of Kadya Molodowsky*, translated by Kathryn Hellerstein, was published by Wayne State University Press in 1999.

Nawat Naffaa' was born in the village of Beit Jann in northern Israel. She is a graduate of Oranim College Library School and the Haifa University Department of Creative Arts. She now works as a librarian at Gordon College. Her poetry has appeared in numerous journals and anthologies of work by young Palestine poets. Naffaa' says, "I consider myself someone who creates in two languages—a visual one in painting, and textual language in poetry. Each language has its own existence, not necessarily dependent on the other or created through it. At times I try to merge the two."

Aida Nasrallah, the pen name of Mahammeed Nasra, was born in 1958 in Uhm el Fahm, Israel. She teaches at the High School for the Arts in Naamat, and organized and ran a weekly salon for women poets and writers, serving as a mentor for Arab women in Israel who wish to experiment with poetry and fiction. Most recently, she was the driving force behind an art exhibit, "Common Threads," that displayed the work of Jewish and Arab women artists side by side at the prestigious gallery of Tel Aviv University. She has published more than 40 short stories and 60 poems in various Arabic publications in Israel.

Tal Nitzan is a poet, editor, and translator from Spanish and English to Hebrew. Born in Jaffa, she has lived in Buenos Aires, Bogotá, and New York and currently lives in Tel Aviv. She was the winner of the Women Writers Prize in 1998 and the Culture Minister's Prize for beginning poets in 2001. Her book, *Domestica* (2002), won the Culture Minister's Prize for a first poetry book. Her second poetry book, *An Ordinary Evening*, was published in 2005. Her poems have been translated into English, French, Spanish, and Arabic. She has a special interest in literary peace activism, and has organized several political-poetic events and edited *With a Pen of Iron* (2005), an anthology of 99 Hebrew poems of the past 20 years that protest against the Israeli occupation of Palestine. She has translated more than 40 books, among them poetry by Miguel de Cervantes, Antonio Machado, Pablo Neruda, Octavio Paz, Jorge Luis Borges, César Vallejo, Alejandra Pizarnik, and José Hierro, and prose by Miguel de Cervantes, Gabriel García Márquez, Mario Vargas Llosa, Julio Cortázar, Juan Carlos Onetti, Toni Morrison, Ian McEwan, Angela Carter, and many others. She has won several prizes for her translations, among them the Culture Minister's Prize for translators (1995, 2005), and in 2004, an honorary medal from Chile's president for her translation of Pablo Neruda's poetry.

Esther Orner was born in Germany in 1937 to Polish parents. In 1939, her family sought refuge in Belgium and in 1950, at the age of 13, she immigrated to Israel, where she completed her high school and university education. From 1963 to 1983 she lived in France, where she began writing in French. After 1983 she returned to Israel to live in Tel Aviv. Orner is the author of six books in French as well as numerous translations of prominent Israeli poets, including Yehuda Amichai, Sabina Messeg, and Amir Or.

Hava Pinhas-Cohen is a poet, editor, and lecturer in literature and art. She received her bachelor of arts degree in Hebrew literature and art history in 1979 from the Hebrew University in Jerusalem. She is currently writing a thesis on the connection between classic Jewish *midrash* and modern Hebrew literature. Pinhas-Cohen's style incorporates the many layers of the Hebrew language and highlights the inter-textual relations with classic and modern Jewish sources. Her subjects include the relationship between man and creator, questions on the essence of faith, the presence of death within life, and the intimate journey into the feminine psyche. Pinhas-Cohen is the founder and editor-in-chief of *Dimui: A Journal of Literature, the Arts, and Jewish Culture*, an interdiscipli-

nary journal that explores Jewish culture and the ties between the Jewish and Israeli world, as well as the inner dialogue of the Jewish world and its reflection in local literature, poetry, and the arts.

Dahlia Ravikovitch was born in 1936 in Ramat Gan, a suburb of Tel Aviv. She studied at the Hebrew University in Jerusalem, and later worked as a journalist and teacher. She has published five volumes of poetry: *The Lover of an Orange, A Hard Winter, The Third Book, Deep Calleth Unto Deep,* and *Real Love;* a book of short stories, *A Death in the Family;* and two books of poetry for children, *Family Party* and *Mixed-Up Mommy*. She is the recipient of many of Israel's literary awards: the Shlonsky, Brenner, Ussishkin, and Bialik prizes, as well as the award of the Municipality of Ramat Gan. She now lives in Tel Aviv with her husband and son, and writes television reviews for the newspaper *Ma'ariv*.

Hadassah Rubin was born in Yampol, Ukraine, in 1912. She became involved at an early age with the Communist movement. Living in Vilna before the outbreak of World War II, Rubin began publishing her Yiddish poems and joined the literary group Yung Vilna. After spending the war years in the Soviet Union, Rubin returned to Poland, then made *aliyah* to Israel in 1960, settling in Haifa. In Warsaw, Rubin published three books of poetry, and in Israel four more, the most recent being *Rays nisht op di blum (Don't Pick This Flower,)* 1995. She died in Tel Aviv on January 7, 2003.

Gali-Dana Singer was born in 1962 in Leningrad (now St. Petersburg), where she studied at the Institute for Theater, Music and Film; she immigrated to Israel in 1988. A poet, translator, and editor of literary magazines and anthologies in Russian and Hebrew, she is currently co-editor of the bilingual magazine *Colon*. Her work has appeared in every major literary magazine in Israel as well as in magazines in Russia, France, Great Britain, and the United States, on the Rotterdam-based Poetry International Web site, and in a University of Iowa anthology of English translations of Russian-language women poets. Three volumes of her poetry have been published in Russian, and two in Hebrew; she is the recipient of the Yair Tzaban 1998 Prize for non-Hebrew writers, and the Prime Minister 2004 Prize for Hebrew writers. *Shalom Aleichem,* her anthology of translations of 50 years of Israeli poetry, was published in Moscow in 1998. Singer has participated in the Israeli Poetry Festival in Metulla four times, winning its Poetry 2000 Prize, and in the International Jerusalem Poets Festival.

Noga Tornapolsky, originally from Argentina, is an author and journalist now living in Jerusalem. She has written articles for *Forward* and *The New York Times*. Several of her family members were "disappeared" in 1976 during the dictatorship in Argentina.

Fadwa Tuqan was born in Nablus in 1917 to a prominent literary family. Tuqan was one of the early Palestinian and Arab woman poets to publish poetry and literature, laying the foundation for feminine explorations of love and social protest. Her first volume, *Alone with the Days*, was published in 1952. Tuqan studied English literature at Oxford University for two years. Her book *A Mountainous Journey* (1958) is a poetic autobiography. Tuqan wrote from her own experience and for her late brothers, one of whom is the most famous Palestine poet of his time.

Rachel Tzvia Back is a poet, translator, and professor of literature who has lived in Israel since 1980 and in the Galilee since 2000. She is the author of two poetry collections, *Azimuth* (2001) and *The Buffalo Poems* (2003), and of the critical work *Led by Language: the Poetry and Poetics of Susan Howe* (University of Alabama Press). In 1996, Back was a recipient of the Absorption Minister's Award for Immigrant Writers. Most recently she was responsible for the selection, translation, and introduction in *Lea Goldberg: Selected Poetry and Drama* (Toby Press, 2005) and was awarded a 2005 PEN Translation Fund Grant for these translations.

Yona Wallach died in 1985 at age 41, but her work continues to have a profound effect on the Israeli cultural landscape; more than any other late twentieth-century Israeli poet, Wallach changed the way Hebrew poetry is written. Born in Tel Aviv and raised in Kiryat Ono, she never left Israel's borders. *The Selected Poems of Yona Wallach 1963–1985* was first published in Israel in 1992. Her other books include *Things* (1966), *Two Gardens* (1969), *Poetry* (1976), *Wild Light* (1983), *Forms* (1985), and *Appearance* (1985). An expanded translation of her work, *Let the Words: Yona Wallach*, translated by Linda Zisquit, was published in 2006.

Julia Wiener was born in Moscow and is a graduate of the State Film School in scriptwriting. She emigrated to Israel in 1971 and earns her living alternately as a scriptwriter and a literary translator. Wiener publishes verse and prose in Russia and in Russian-language magazines in Israel; some of her poetry has been translated and published in He-

brew as well. She currently lives in Jerusalem.

Nurit Zarchi was born in 1941 in Jerusalem. Her father, Israel Zarchi, was an author and her mother was a teacher. After her father's death, when Zarchi was six, her mother moved with her to Kibbutz Geva. Zarchi was raised in the kibbutz, and during her military service she trained as a teacher. Later she returned to Jerusalem to study humanities at the Hebrew University. She has worked as a journalist and published essays about literature and art. Zarchi teaches creative writing to university students and conducts workshops for adults and young adults

Linda Zisquit was born in Buffalo, New York, and educated at Tufts University, Harvard University, and SUNY Buffalo. She has published three full-length collections of poetry, *Ritual Bath* (1993); *Unopened Letters* (1996); and *The Face in the Window* (2004), Her translations from Hebrew include *Desert Poems* by Yehuda Amichai (1991); *The Book of Ruth* (with woodcuts by Maty Grunberg) 1997; and *Wild Light: Selected Poems of Yona Wallach* (1997), for which she won an NEA Translation Grant and was short-listed for a PEN Translation Award. She has lived in Israel since 1978 with her husband and five children; she teaches at Bar-Ilan University and runs ARTSPACE, a gallery in Jerusalem representing contemporary Israeli artists. Her expanded collection of translations from the work of Yona Wallach was published in 2006, and she has recently completed a collection of translations from the work of Israeli poet Rivka Miriam.